S J PEPLOE
1871-1935

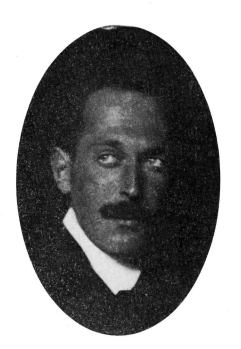

1 Portrait of S J Peploe *c. 1895*

ISBN 0 11 492456 2

The Scottish National Gallery of Modern Art gratefully acknowledges the financial support of Robert Fleming Holdings Ltd.

Photographic credits
Aberdeen Art Gallery and Museums 90. Col. plate 16 (116)
Annan, Glasgow 18, 35, 84, 92, 93, 125, 130
Christie and Edmiston's, Glasgow Col. plate 3 (34)
A C Cooper, London 36, 45, 85, 131. Col. plate 12 (79)
Courtauld Institute of Art 127
The Burrell Collection, Glasgow Museums and Art Galleries 8
Glasgow Art Gallery and Museum 9, 27, 70, 81, 86, 94, 96, 152
Hunterian Art Gallery, University of Glasgow 95, 97, 148
University of Hull Art Collection Col. plate 10 (69)
The Ideal Studio, Edinburgh 106
Kirkcaldy Art Gallery 47, 48, 52, 111, 121, 122, 156, 206
Jack McKenzie, Edinburgh fig. nos. 1-6. Cat. nos. 1, 4, 5, 17, 23, 24, 28, 32, 42, 44, 50, 54, 57, 66, 71, 75, 80, 82, 99, 102, 104, 110, 114, 115, 119, 133, 137, 164, 166, 167, 169, 170, 189. Col. plates 1 (26); 2 (30); 4 (40); 5 (49); 6 (51); 7 (53); 8 (61); 9 (62); 11 (72); 13 (100); 15 (108); 17 (157). Cover illustration (105)
Manchester City Art Galleries Col. plate 14 (107)
St Andrews Photographic Unit 3, 74
Tom Scott, Edinburgh 14, 31, 37, 55, 83, 101, 117, 140
City Museums, Stoke-on-Trent 67
John Watt, Perth 124

Cover illustration: Palm trees, Antibes *1928* (105)

FOREWORD

In these times, when picture-making has become highly problematic, an act of ironic self-awareness, it is both refreshing and instructive to look back to a time, when *belle peinture* was part of a lively, creative tradition. Now that that tradition has been seriously interrupted, if not completely severed, by the irony of Duchamp and the distancing effects of conceptual art, it is beneficial to consider how important a sensuous enjoyment of colour and form once were (and perhaps still are!) to painting.

Belle peinture is a tradition that has been strong in Scotland, particularly since the late nineteenth century, when strong artistic links with France were once more taken up by the 'Glasgow Boys'. France, of course, is the home of this tradition and it was to France that Peploe, like the 'Glasgow Boys' before him, turned throughout his life for artistic stimulus. Perhaps more than any other Scottish artist this century Peploe was concerned with picture-making, placing it above personal expression or characterisation of the motif. Indeed, in his pictures, whether they be still lifes, landscapes or even figure pieces, we learn very little about the artist's feelings or the things he paints. Peploe was above all interested in the paint and the way it went on to the canvas. This was just as true in his early, fluidly painted near monochrome pictures as in his later attempts to forge a perfect harmony between high pitched colours and interlocking forms. It is not to belittle Peploe's art to say that he did not have Cézanne's relentless desire to capture the essence of a motif, nor Matisse's boldness in exaggerating a colour or a form so as to express it and himself more clearly. Peploe was not a revolutionary and never developed any aspect of his art to the limits of its logic as did Cézanne or Matisse. But what he did do supremely well was to balance the competing demands of pure colour, interrelated form and of the motif itself. To develop any of these elements any further would have destroyed this fragile balance and sent his work either in the direction of expressionism or of realism. Some today would criticise Peploe's *juste milieu* as timid and lacking in intellectual vigour, but that would be to ignore the values of consolidation and of a well-rounded, balanced viewpoint.

The popularity of Peploe's paintings has never substantially waned in Scotland since the artist first made his reputation before the First World War. Over the past few years his work has been increasingly appreciated south of the border and abroad. We hope that this exhibition — the largest ever mounted — will reinforce that trend and at the same time lead on to more scholarly research. We are very grateful to the private collectors and museums for lending their paintings and drawings so generously to this exhibition. We realise how difficult it is to part with treasured possessions especially when, in some cases, these amount to several paintings. I would like to thank Guy Peploe, the artist's grandson, who has chosen the works, and written the introduction and catalogue entries. His very special connections and knowledge of his grandfather's work have made this exhibition possible. I would also like to thank Fiona Pearson, Research Assistant, for collating all the material and Moira Spence for her unending patience in typing it all out. Last but not least I would like to thank Robert Fleming Holdings Ltd., for the financial assistance that they have given to this project.

Keith Hartley

CONTENTS

S J PEPLOE
PAINTER IN OILS

Fifty years have passed since the death of one of Scotland's greatest painters, and in this exhibition it is hoped that many will recognise the debt we owe to Samuel John Peploe.

His working life spanned a period of unparalleled change in European art from the hey-day of Paris in the gay nineties through the emergence and acceptance of a cathartic *avant-garde* and into the depressed, politically troubled thirties.

He was born on January 27, 1871 into a genteel Edinburgh household at 39 Manor Place. His father, Robert Luff-Peploe, was Assistant Secretary of the Commercial Bank of Scotland. His mother, née Anne Hickock Wilson, died when he was only three. He had a sister Annie and an older brother William, as well as a half-brother, James, from his father's first marriage to Mary Seymour Mendell. When his father died in 1883 Sam was attending the Collegiate School in Charlotte Square. No juvenilia has survived but we know that his trustees and half-brother resisted the idea of his becoming a painter, offering the army and law as serious options. That he persisted is a measure of his convictions and with the stern warning from the senior partner of the legal firm, for which he had begun to work, that 'the divine afflatus is often confused with wind', he entered classes at the nascent Edinburgh College of Art. The following year, 1894, he was in Paris, first at the Académie Julien working under the elderly neo-classicist William Bouguereau and later at the Académie Colarossi, where he won a silver medal.

Throughout his life Peploe enjoyed very close relationships with fellow artists. He loved stimulating company and benefited from the insights that working closely with another artist offered. In his student days the painter Robert Brough, from Aberdeen, was his closest friend. They shared models in Edinburgh and rooms in Paris. Tragically Brough was killed in a train crash in 1905 at the beginning of a very promising career. R C Robertson was another painter who worked with Peploe in the nineties. Together with Willie, Sam's brother, they painted on the Island of Barra in the Hebrides from 1894 onwards.

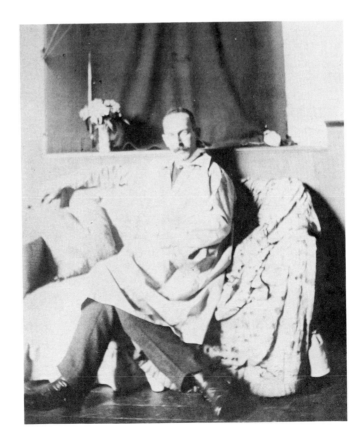

2 S J Peploe in his Devon Place Studio *c. 1904*

Many early drawings show the strong influence of French and Glasgow School realism, of Millet and W Y MacGregor, both in subject matter and style. *Girl feeding the hens* (145) is typically rustic but not romanticised. A small landscape of c. 1895 (1) indicates an affinity with Corot. (Compare it, for example, with Corot's *Ville d'Avray* in the National Gallery of Scotland.) He would have had the opportunity to see examples of such Continental painting at Alexander Reid's Gallery in Glasgow. Reid, who knew the Van Gogh brothers and had had his portrait painted by Vincent in 1887, introduced the Barbizon painters as well as the Hague School to Scotland with considerable success. He was later to take up Peploe and Leslie Hunter and be a loyal devotee and promoter of their work. In Paris Brough was influenced by the peasant paintings of Émile Bernard and Maurice Denis, while Peploe absorbed himself in the French still life tradition from Chardin to Manet. From the mid-1890s on he began to paint still life subjects of flowers, fruit and simple household objects such as knives, crockery and bottles. Peploe's *Dish of roses* (5), for example, is close in spirit to the still lifes of Courbet and Manet. He also looked to the art of previous centuries: to Velázquez and early seventeenth-century Dutch painting (in particular Frans Hals). He was in Amsterdam in 1895 and it is recorded how he waited patiently for the Rijksmuseum to open, made a bee-line for the Hals room, ducked under the ropes and feasted in close-up on the master's technique.

From about this time he began to work in the Albert Buildings on Shandwick Place, a warren of studios and rooms full of activity. Edinburgh did have a Bohemian side in those days before successive councils sanitised the city, clearing away the coffee-stalls and street-traders from Princes Street. Peploe found a perfect model in Jeannie Blyth, a flower-girl from a well-known Edinburgh gipsy family. He painted her many times over a ten-year period.

The dark studio suited Peploe's taste and a dark background, usually black or a brown such as burnt sienna, was the starting point for the still lifes, nudes and figure studies he was painting at the time. Between the dark background and the highlights, his colour scheme is constructed so that each colour is weighted and positioned according to its tonal value. *Painting materials* (4) is a good example of this type of picture. Throughout his life he had a real enthusiasm for the minutiae of technique and worked hard to perfect his method. This endeavour made him well aware of the demanding nature of oil painting. Indeed, he likened its exigencies to those of ballet, needing a fine physical condition to enable the artist, like the dancer, to relay messages through perfectly controlled gesture. At the end of a day's painting there was often a track worn on the studio floor where Peploe had moved to and from his easel.

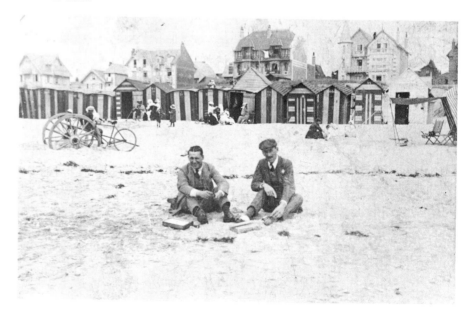

3 S J Peploe (right) and J D Fergusson Paris
 Plage *c. 1907*

By 1900, in a new studio at 6 Devon Place, he had begun to master his difficult medium and become more sophisticated in his choice of subject matter. Tables are draped in linen and arranged with elegant items: a silver coffee-pot, a dish of black grapes, a Chinese porcelain bowl or a crisp white napkin rumpled on a white tablecloth. These paintings rejoice in refinement and civilization. *Still life, coffee pot* (34) is full of sophisticated compositional devices. For example, the orange to the left of the dish has been modelled in an angular fashion to complement the corner of the table. The dashing self-portraits and *The laughing man* (18) show the same virtuosity in controlling the fluid medium. His evident love of the paint itself, which he used with a loaded brush, led him to choose subjects (particularly flowers) which begged for a rich, full-bodied application of paint. This painterly confidence continued in his next studio at 32 York Place which he occupied from 1905. This was a much lighter space and, correspondingly, the tone of Peploe's work lightened. He began to use a model called Peggy Macrae who was popular with many artists because of her striking looks and ability to hold graceful poses.

From about 1904 he began to go on summer sketching holidays with J D Fergusson; once to Islay and then often to Brittany. The work that Peploe did on these trips was invariably on small panels. They are a remarkable series of works, capturing the spirit of place and time with swift assurance. The beach scenes are painted in pinks, blues and greeny-greys, sometimes enlivened with a downward stroke in a darker blue that suggests a bathing tent, a wind-blown figure or a sailing boat. Street scenes, busy with colour and activity, are rendered with dabs and smears of orange, yellow-white, and blue, half of which seem to have been made with paint applied straight from the tube. In Scotland Peploe painted on Barra in 1902 and 1903, and in North Berwick and Comrie in 1903. In the latter town, where his sister and her husband Dr Fred Porter lived, he painted some canvases that, of all his landscapes, are closest to the early impressionism of Pissarro and Sisley. Although he was well aware at that time of the colour theories of Chevreul, and although he was well acquainted with neo-impressionist painting, Peploe was not drawn to a divisionist technique. He was reluctant to abandon the suggestive possibilities of line and the immediacy of *plein-air* painting. For Peploe, landscape painting was a fresh air, intuitive activity, and one feels, looking at his Brittany paintings, for example, that his painterly skills allowed him to perform like an intelligent camera and capture a fleeting sunburst while he held his breath.

Peploe showed his pictures (sparingly) at the Royal Glasgow Institute, the Royal Scottish Academy and the Society of Scottish Artists, and had his first one-man show at Aitken Dott & Son in October 1903, when he sold 19 pictures. Peter McOmish Dott took a great interest in the young Peploe and contributed much to his early success. It was Peploe's reticence that made him wait five and a half years before his second show at "Dott's", in March 1909. Preferring, as always, as little complication as possible in his dealings with galleries, Peploe was happy to accept £450 for the 60 paintings in the show. This money allowed Peploe to marry and shortly afterwards to move to Paris. The show was a great success. 35 paintings sold, as well as a good quantity of drawings. (Drawings formed an important part of his early shows.) During 1908-1910 Peploe was shown in three London venues and enjoyed much critical acclaim. At the first exhibition of the Allied Artists' Association at the Albert Hall in the summer of 1908, Peploe was singled out for particular praise amongst over 1,000 exhibitors. At the following year's event the *Observer* critic found his *Still life* (of plums, melon and knife against a black background): "The nearest approach to mastery in the whole exhibition." Probably as a result of the press attention Peploe took part in several shows at the Goupil and Baillie Galleries during these years.

Peploe was bored with Edinburgh, perhaps a little alarmed by his increasing popularity and sick of having "Wingate and MacTaggart crammed down my throat". His name came up for election to the Royal Scottish Academy and was rejected. He expressed delight at this. As David Foggie wrote for *The Scotsman* on the occasion of the 1936 Aitken Dott Memorial Exhibition: "Peploe had reached an impasse created

by his own virtuosity." It was time for a move and Paris was the obvious choice because he knew it well and it was where Fergusson had been urging him to move for some time. In the early summer of 1910 Peploe married Margaret Mackay who came from South Uist. He had met and fallen in love with her seventeen years previously when she had been working in a hotel on Barra.

The couple rented and decorated a large studio apartment at 278 Boulevard Raspail, quite close to the Luxembourg Gardens where Peploe had often sketched. Paris seemed a city full of energy and the spirit of change and it was a time of optimism for the arts. There were visits to Diaghilev's *Russian Ballet* to see Nijinsky, Fokine and Karsavina, and the designs of Bakst and Tchelitchew. It was also a time of feverish hard work, of meetings with the leading figures of the *avant-garde*. A close-knit group of friends enjoyed this rich cocktail. It included J D Fergusson and his talented American girl-friend Anne Estelle Rice, Jessie King and E A Taylor, Jo Davidson, a fashionable American portrait sculptor, Yvonne and Louis de Kerstratt and others. Peploe exhibited at the Salon D'Automne (of which Fergusson was a *Sociétaire*), and it was through this that he met Bourdelle, Friesz, Pascin and Picasso. It was also through Fergusson (the art editor) that he came to have six of his drawings reproduced in the short-lived, *avant-garde* journal *Rhythm* between the summer of 1911 and the spring of 1912. Other artist contributors included Chabaud as well as Picasso and Derain.

It is difficult to discern what influences were working on Peploe in Paris and easier to understand his initial essays in landscape as being a development of what he had been doing in the previous few years. Although there are similarities with the work of the fauves, Peploe's technique is looser, and his range of colours is narrower. He varied the length and direction of his brushstrokes and he seemed to baulk at using the hot reds beloved of Matisse and Derain. Peploe's small panels of Parisian parks and streets continue to show his ecstatic love of life, and his desire to express this as immediately and spontaneously as possible in colour and oil paint. In his studio he worked with a furious energy which is visible in the works themselves. The paint is worked into furrows even more markedly than in the pictures of the mature Van Gogh. Indeed Van Gogh was a powerful influence on Peploe at this time, as he had been on the young fauves. It was a period of experiment and inventiveness for Peploe, when he might pose a vase of yellow tulips against a bright yellow background with complete success. His palette was devoid of half-tones or dark colours. Blue and yellow dominated. But for all their *joie-de-vivre* these paintings sometimes lack *gravitas*. Their energy seems to have required the sacrifice of some of the thoughtful drawing and composition that underpins his most lasting work.

In the summer of 1910, the Peploes were at Royan on the Atlantic coast of France, where his wife gave birth to their son, Willie, while Sam was painting the harbour. The works that he painted at this elegant Edwardian resort are similar in style to his earlier French seascapes. But the next year, on the Île de Bréhat, there is a distinct advance away from an impressionistic treatment. The landscapes are built up in planes of colour which are surrounded by dark outlines. These planes are given special meaning by the angle of the strong brushstrokes they contain. But this was as far as he took this method in his landscapes.

He returned to Edinburgh in April 1911 to try to raise money to continue living in Paris. The letters to his wife and young child are very touching and revealing of his attitude: *"I went down to see Dott this morning about those pictures. He was out so I saw Proudfoot. The offer was £50 for 22 canvases! He apologised for the smallness of the amount but said it was more than I would get in a saleroom. Pictures are not selling at the moment. It was all I could do. I accepted it . . . No one here seems to care the least for the things that are so great to me. I shall be heartily glad to get back to Paris—at least there one doesn't have to constantly

*The quotations come from letters in a private archive hitherto unpublished.

4 Portrait of S J Peploe

explain oneself. If I clear £100 on my trip I shall be jolly pleased. . . . I know my last work is my best and the best is yet to come. If I can just get through the next two or three years I am sure things will get better. I might have been wiser to have hung on and not sold these things but I am sick of them." There are many references to his 'old work', which he recognised as brilliant but which did not interest him any more. There is also much complaint about the dullness and conventionality of Edinburgh. "I met Annie Blyth [the daughter of Jeannie, his former model] in Princes Street this afternoon and we talked for half an hour—I felt so much sympathy with her—a thousand times more so than with those long-faced lawyers and red-cheeked girls. There's nothing here but healthy-looking people with golf clubs." But he did have some assistance from Alexander Reid who introduced him to William Burrell (who eventually acquired four Peploes), and from John Ressich, a Glasgow businessman who endeavoured to sell some French work from his office. He also had welcome sympathy from Mabel Royds and Arthur Kay. With great energy and a new-found confidence he began to convert people to the new work, a few examples of which he had brought back with him and was thus able to sow seeds for successful relationships on his permanent return.

In the early summer of 1912 the Peploes returned to Edinburgh and quickly bought a flat at 13 India Street. They returned probably because they wished to raise a family in Britain and also because Sam had arranged an exhibition at Dott's. Peter McOmish Dott, however, could not accept his new French work. An alternative venue was found at The Society of Eight's premises at the New Gallery in Shandwick Place the following year. The exhibition was largely ignored. Peploe must have been very disillusioned. As early as June 1912 he had written to his wife in Lochboisdale from his newly refurbished studio at 34 Queen Street: "I am very lonely. I have no one to talk to. I can't bother other people with my enthusiasm. No one can call me a bore. As I wired you I have unpacked my French things and the

studio is like a conservatory. They stand all round the room—the place is flooded with them. I was quite excited opening the bundles and coming on the canvases. I wished to have someone with me to see them. And this morning I was busy looking out more drawings—at present there are sixty lying on the floor and they look very well—make quite a show. But I don't think I'll send them all to Nevill. . . . As I told you he sold four the private view day. I wonder what price he got. When I look around my studio just now I feel rich—I can't help believing that some day these things will bring in money, only I must be more businesslike and not chuck them away. Ressich sent me £4 for a drawing; it was priced £3 so at any rate he is honest."

The 'Nevill' referred to in this letter was John Nevill of the Stafford Gallery, London, where Peploe had had a very well received exhibition of his drawings. The critic of *The Evening Standard* had written: "Almost alone among the good draughtsmen of today, Mr Peploe draws without any ulterior motive. He is like a good writer, so absorbed in his subject that style results automatically from the desire for perfect expression. The range of his artistic appreciation is extraordinarily wide, and in each case the thing is drawn as if it were the most important thing in the world." These praises are pertinent reminders of the importance of drawing to Peploe, whether as preparatory work for his paintings or as a separate exercise. He drew from direct, perspicacious observation and with unselfconscious virtuosity. In October 1912 he showed in two group exhibitions in London with three works at the Grosvenor Gallery and four at the Stafford Gallery. The exposure of his French work received mixed responses. The critic of *The Daily Chronicle* commented: "Mr Peploe's group of still lifes and landscapes (at the Stafford Gallery) is the outstanding feature of the show. He paints with radiant decision. His centre-piece composed of a pot, flowers and fruit, sings from the wall. Why was this branch of British Post-Impressionism ignored by the directors of the Grafton Gallery—this branch that is so fresh and alive?" In retrospect one can certainly see the omission of Peploe and Fergusson from the post-impressionist exhibitions, masterminded by Roger Fry, as an oversight. There has been a traditional ignorance about Scottish art in England. In his *Thirty Years of British Art* (The Studio, 1930), Sir Joseph Duveen reproduced *Boy reading* (85) but did not deign to comment. This metropolitan bias in attitude has been a perennial source of frustration to the 'regions'. (Time, however, has a reassuring way of balancing opinion and quality will always come out. Part of the fault lies with a nationalist desire among Scots observers to preserve a painter such as Peploe as exemplary, working purely in a Scottish tradition and isolated from larger currents.)

In the last few months in Paris and the first two years in his Queen Street studio, Peploe painted a series of still lifes which were described as 'cubistic' by the critic of *The Scotsman*, after he had visited the annual exhibition of the Society of Scottish Artists in 1913. In *Still life* (62) there is no shadow or 'real' space. The reality of the objects is subordinate to the abstract design of the whole. *Anemones* (63) which is slightly later, has similar qualities of angularity but there is a new concentration on the motif and the abstract background has been eliminated. The heavy outlines are characteristic of these paintings and are an effect Peploe is known to have admired in the work of the French painter Chabaud. They serve to contain colour but not to emphasise its two-dimensionality as they had done in Chabaud's work. They emphasise, instead, the structure of the objects and the relationships between those objects. At the same time Peploe achieves a new monumentality by recognising the inherent splendour of simple objects, a concern which will occupy him to a greater or lesser degree for the rest of his life. For the next few years it is a very real, sometimes stark space which Peploe seeks to fill with his fruit, fabrics and simple studio props. Paul Cézanne is his great exemplar. It is difficult to quantify the importance of Cézanne to Peploe, but it is by no means superficial, either in philosophy or in methodology. Stanley Cursiter quotes from a letter by Peploe written in 1929: "There is so much in mere objects, flowers, leaves, jugs, what not—colours, forms, relation—I can never see mystery coming to an end." In similar vein, Cézanne, writing to his son a few weeks before he died, described a view by a river: "The same subject seen from a different angle gives a motif of the highest interest, and so varied I think I could be occupied for months without

changing my place." Both men were inspired by an infinity of relationships in nature all worthy of close examination. Some of Peploe's pictures such as *The blue and white teapot*, c. 1917 (74) do seem to owe a direct debt to Cézanne. Compare, for example, *Nature morte à la cruche* (c. 1892-3, Tate Gallery).

Back in Paris the Peploe family were persuaded to spend some time in Cassis. This unpretentious seaside resort on the Calanque coast between Marseille and Toulon became a favourite holiday venue to which Peploe returned in 1913, 1924 and 1928. The brilliant sunshine of the Midi which gave a crisp definition to the buildings and created deep rich shadows, helped Peploe to achieve a tighter control of his masses and encouraged him to use colour at a fauvist pitch. Blue and orange provided the dominant chords, with shadows made up of green, turquoise, grey and orange.

From about 1914 until his death, Peploe sought to paint the perfect still life. There are many changes in technique and temperament but not in purpose. With tireless, almost obsessive energy he tried to construct the significant out of the commonplace. A lovely illustration is provided by Peploe's aspidistra which he painted many times, trying to find in this Mr Pooter of plants a subject worthy of high discourse. This he achieved in *Aspidistra* (99) which is a most sophisticated and eloquent painting. Without disguising the dusty colours and familiar form he has painted a monumental portrait of the plant. Against a pale monochrome background the tough leaves curl outward and in; the design they create is almost mannerist in complexity. He might paint the same flowers, roses or tulips (depending on season), three times in a week. He concentrated on a few simple props: Chinese vases, a black fan, a blue jug, books, the 'Raeburn' chair, fruit, and patterned fabrics, often bought from Whytock and Reid. (Many of these items also appear in still lifes by Cadell which demonstrates the degree of co-operation and understanding between the two painters.) What seems to be repetition should be understood as a finely tuned sensibility playing subtle variations on a theme. In *Roses* (59) and *Roses in a Chinese vase* (87) the vase and the space remain constant, but the substitution of a red for a blue tablecloth alone makes the one painting a very different visual experience from the other. The comparison makes one realise the extraordinary care Peploe took over the composition of his still lifes.

The Queen Street years saw the development of a close working relationship between Peploe and Aitken Dott's (through George Proudfoot) and also with Alexander Reid (who amalgamated with the Lefevre Galleries in 1926). Peploe was happy to let the dealers select what they wished while he took a walk, and they, in return for this exclusive right, gave him a guaranteed income. He badly needed security, now that a second son, Denis, had been born in 1914. He showed regularly in Edinburgh at Aitken Dott's and, through Reid & Lefevre, in Glasgow and London. He once showed in New York, thanks chiefly to the energy of Duncan MacDonald who was the most active partner in Reid & Lefevre after 'Old Reid' retired. The bread and butter sales came from Scotland where he was supported by a small group of collectors to a remarkable degree. J W Blyth bought over eighty of his works, Robert Wemyss-Honeyman over forty and Major Ion Harrison a similar number.

The Luxembourg Museum in Paris bought its first Peploe from the 1924 show at the Galerie Barbazanges. It was at this show that Peploe exhibited alongside F C B Cadell and Leslie Hunter. It was one of the first of many such group shows, and, from then onwards, Peploe's name was often associated with the other two, and also sometimes with J D Fergusson. The group later became conveniently labelled 'The Scottish Colourists', though they were never a real 'school'. All used colour in a high key; their work was based on observation of nature and was free of any anxiety; it was forthright and fresh. But their differences were manifold. Cadell, who, like Peploe, lived in Edinburgh, could be close to him in choice of subject, but in his later work, the edges were harder and he tended to emphasise the two-dimensional design of his canvases. His colour could border on the discordant. Leslie Hunter who was the most peripatetic of the three, hardly knew Peploe. His use of colour is less intellectually ordered and at times could be muddied through overworking.

After his return from Paris Peploe turned first to the south-west of Scotland to paint landscapes. He went to Arran in 1913 where he delved deep to expose the bones of the rugged island, using strong directional brushwork and a stark black and green tonality. In 1914 he went to Crawford and to Kirkcudbright, where his friends E A Taylor and Jessie King had made their home. It proved a very productive area and the venue for happy family holidays. (In 1919 Jessie King organised a great pageant in the town. She made elaborate costumes for the townsfolk and Sam willingly played the part of the pied piper, leading the children through the streets with his penny whistle.) The old Tolbooth and Castle became common motifs in carefully organised, planar paintings. In 1920, encouraged by Cadell, Peploe went to Iona while the family continued to South Uist. Iona became very special to Peploe and he hardly missed a summer visit in the next thirteen years. He quickly preferred the north end of the island with its craggy rocks emerging from pink sands and its views across the Sound to Mull. The works that Peploe painted on Iona mellowed from the schematic, as in *Cathedral Rock* (80), to a more lyrical expansive treatment in the late twenties. He always painted *plein air*, finishing a painting at a single sitting, and was constantly prey to the vicissitudes of the Scottish climate. The colours of this Hebridean idyll, pinks and ochres, turquoise, deep ultramarine and cerulean blue, olive greens and white shifting to grey, are captured with remarkable acuity and sensitivity. His handling of them reached a peak of development in *White sand Iona, view of Ben More* (113) c. 1928. Iona was more than a picture post-card island where, by working hard on readily saleable pictures, Peploe could pay his children's school fees. It was a sanctuary, where Peploe could enjoy a deep spiritual union with nature. It provided inspiration and enriched the creative process. The whole island was his Mt St Victoire.

In the last fifteen years of his life the work that Peploe did in his studio showed a great range of experiment. He painted almost exclusively on a gesso ground of varying depth. This absorbed the paint so that it could not be scraped out the next day. Within this difficult technical framework he could achieve a considerable variety of finishes. The pigment could be carried in a medium of turpentine and applied in bold streaks which he often used for the stems of his roses. In the still lifes of the early 1920s which characteristically included roses, a compotier of fruit, and books (for example, *Still life with melon* (83)) the paint is built up into a crusty surface with a strong physical presence. In the early twenties Peploe blocked out the chief areas of colour in his still lifes: tablecloth, background, fruit, etc. The composition is flooded with light to avoid the half-tones of shadow. The objects float in this light, seemingly defying gravity. From 1925 on Peploe's handling of his paint became looser, and gradually he began to tone down his colours. Paintings

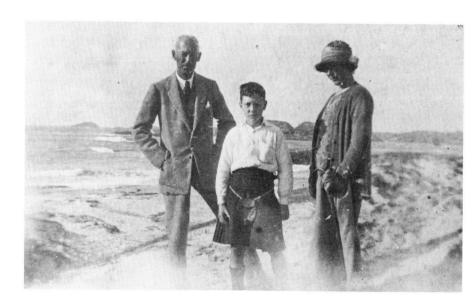

5 S J Peploe with his wife Margaret and
 younger son Denis on Iona *c. 1925*

such as *Pink roses in a jug* (104) and *Michaelmas daisies and oranges* (100) have become more thoughtful and there is re-emphasis on the motif itself rather than its decorative possibilities.

In 1924 the Peploes were in Cassis where Cadell, John McLauchlan Milne and Duncan Grant were also staying. It was then that Peploe perhaps came closest to Cézanne in his landscape paintings. *Landscape, South of France* (93), for example, has strong similarities with the paintings that Cézanne did around Aix in the late 1880s. In 1928 Peploe visited Antibes where he produced some of his finest French paintings (for example, *Antibes* (105)). Palms and olive trees cast deep shadows on the baked earth and the foliage seems to vibrate in the hot air. But the place was far too chic for his taste and he quickly returned to the unpretentious familiarity of the Hôtel Panorama at Cassis. Back in Scotland at Sweetheart Abbey in Dumfriesshire, more splendid work was completed in the late summer colours of Scotland. Peploe used a palette knife to render the grass and sky, feeling intuitively that only depth of paint could record the rich natural abundance.

1928 was a major year. Peploe had an important show at the Kraushaar Gallery in New York, and closer at home, Kirkcaldy Museum and Art Gallery inaugurated their new extension by devoting a whole room to his work—the only living artist to be thus honoured. Having become a full Royal Scottish Academician in 1927, Peploe was by now widely considered the finest artist working in Scotland. His still lifes had attained a new, almost classical monumentality; the jazzy orange had given way to the immutable pear. Pictures such as *Pewter jug and pears* (110) or *Buddha* (114) achieve a contemplative, almost iconic solemnity. His admiration for Chardin had been taken a stage further. There may be strong colour chords but there has been a return to tonal painting: browns, russets, greens and creams are exquisitely modulated across the picture plane.

Increasingly after 1930 the greater freedom seen in his sea- and landscapes is found also in his studio work. Peploe had never disguised the mark of the brush but now the paint became more gestural and colour too is used in a more emotive way. Peploe was becoming more expressionist in his old age. But by 1932 his health was already on the decline. In the summer of 1933 he stayed with A G Sinclair's widow, Louise, at Calvine in Perthshire where he temporarily regained his health. To his own surprise he found much to paint in this, to him, new landscape of slow rivers and ancient trees and the work reflects that freshness. He returned in the autumn and recorded a heavier more sombre aspect of this new-found place. Stanley Cursiter records how he was back in the summer of 1934 but was horrified that a

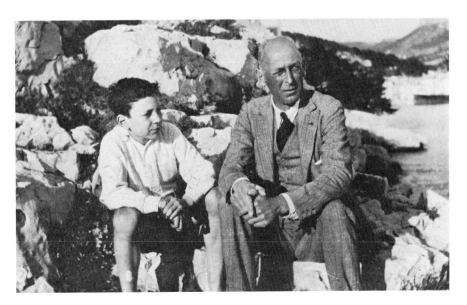

6 S J Peploe and Denis at Cassis, in the South
of France *c. 1924*

road he had enjoyed painting had been tarred over. He fled, depressed, to Rothiemurchus where he painted his last picture. He died on the 11th October 1935 after an operation to remove his thyroid gland. He was courageous, but frustrated by his enfeeblement. He felt that he had much more to give.

Little has been said of Peploe, the man, beyond his deepfelt, almost pantheistic attitude to nature and the great personal integrity which he carried with him to every painting. His wife and family were of tremendous importance to him and his sons knew well the whimsical side of Peploe that many would not have credited—his comic turns and fantastical stories. He loved music, played the piano very well and sometimes sang operatic arias to his own accompaniment. He read avidly and, once, in his youth, wrote to Henry James to beg him to reveal the enigma of *The Turn of the Screw*. There is no evidence of a reply. He also read the latest novels of the day: by D H Lawrence, Aldous Huxley, the Powis brothers, Liam O'Flaherty, Norman Douglas and William Faulkner, as well as detective stories from Gaborieau to Dorothy Sayers. Over six foot tall, he cut a fine figure, dressed in old but immaculately tailored suits. In France his only concession to the heat was a pair of espadrilles and a Panama hat. Those who knew him have described him as shy and aloof. Those who knew him better spoke of his humour, gentle irony, his love of the company of close friends and his uncompromising intellect. The psychologist would probably have found manic tendencies in a man so passionately committed to his art that he was prey to deep depression when things went badly, and whose spirit soared with success.

It is still difficult to assess his importance. He is at once a painter's painter who inspired by example a vital generation of Scottish artists (particularly Gillies, Maxwell and Redpath), and an artist whose work has enormous popular appeal. His lifelong residence in Scotland and the overwhelming domestic consumption of his paintings have perhaps been an impediment to an international reputation, which is, in a way, a prerequisite for assessment in the national artistic Pantheon. Fifty years on, the probity of his line and the harmony of his colours, his asceticism and his hedonism, hand in hand, continue to inform and enrich his public and to reinforce his growing stature.

Guy Peploe

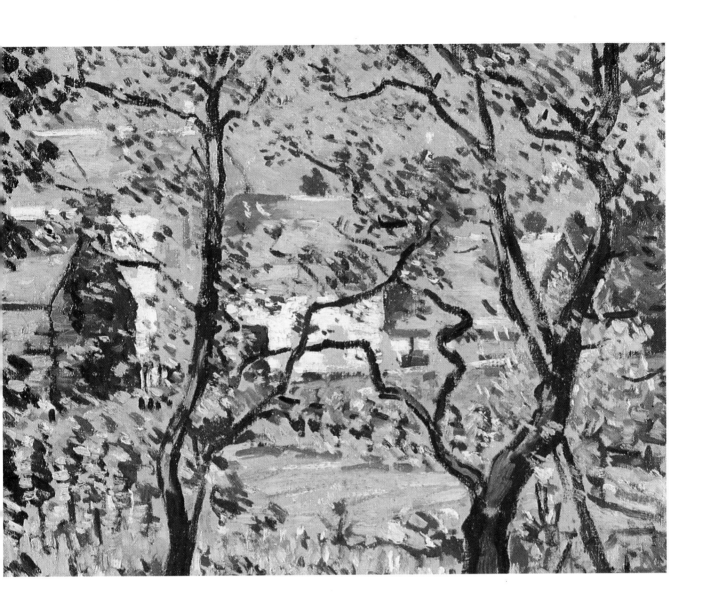

26 Spring, Comrie *c. 1903*

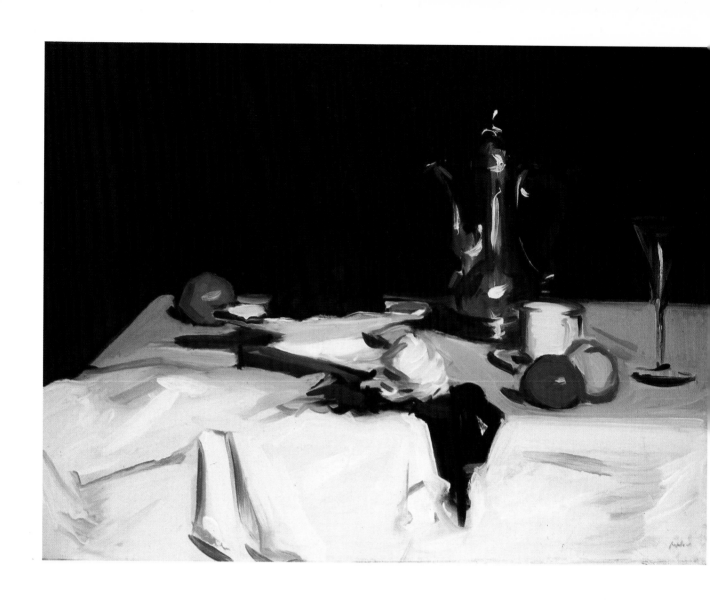

34 Still life with coffee pot *c. 1905*

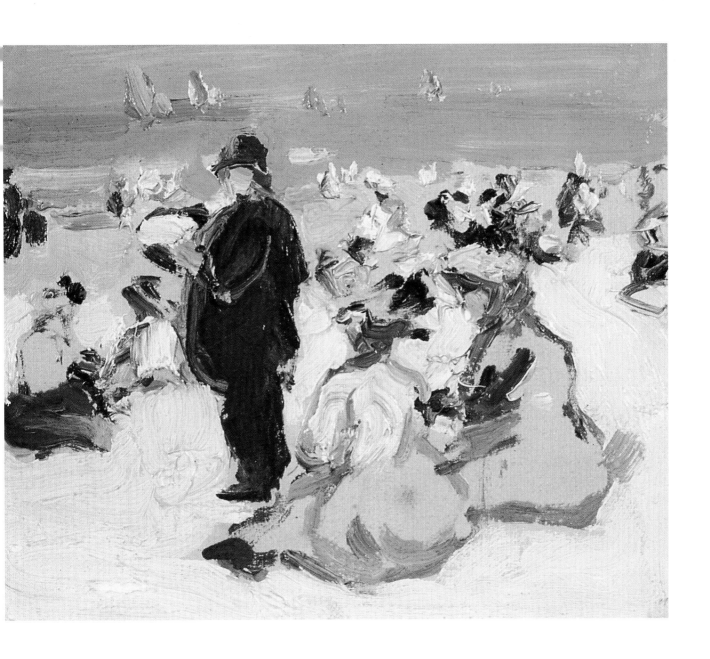

40 Plage scene *1907*

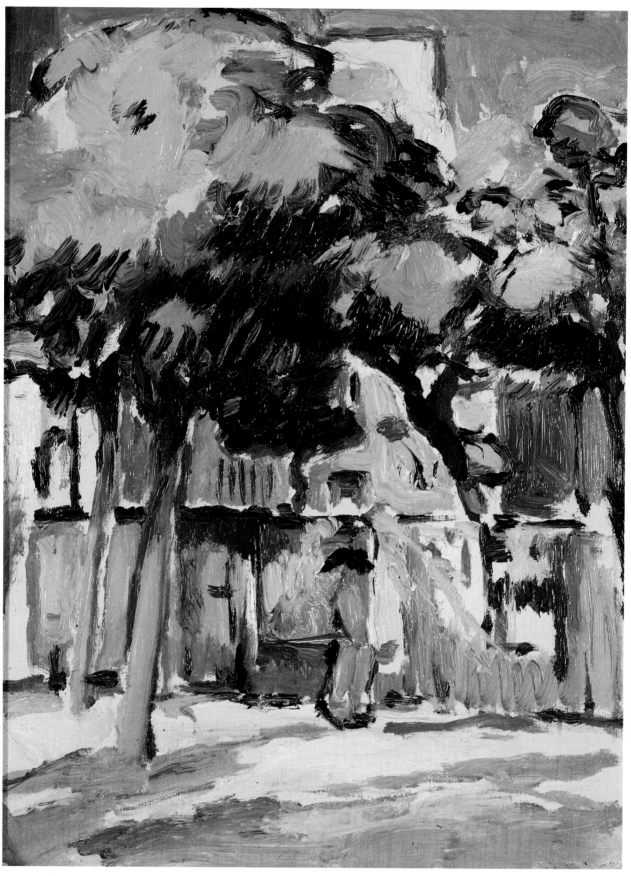

49 Verville les Roses *c. 1910*

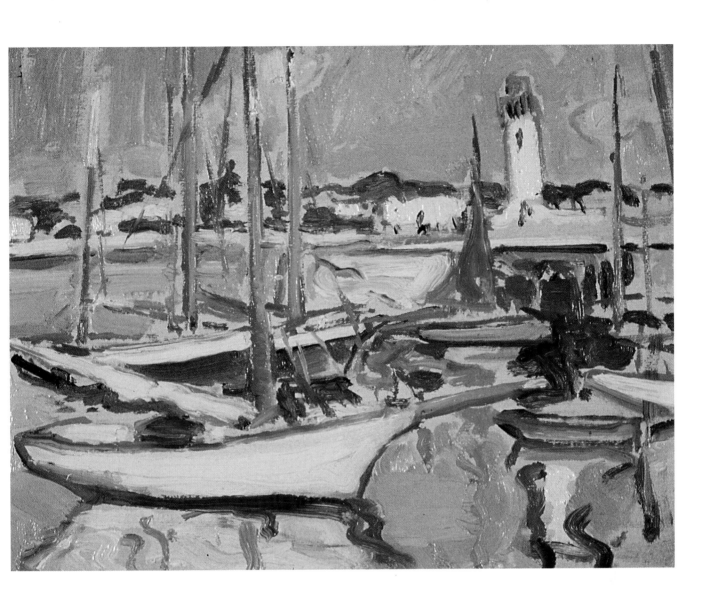

51 Boats at Royan *1910*

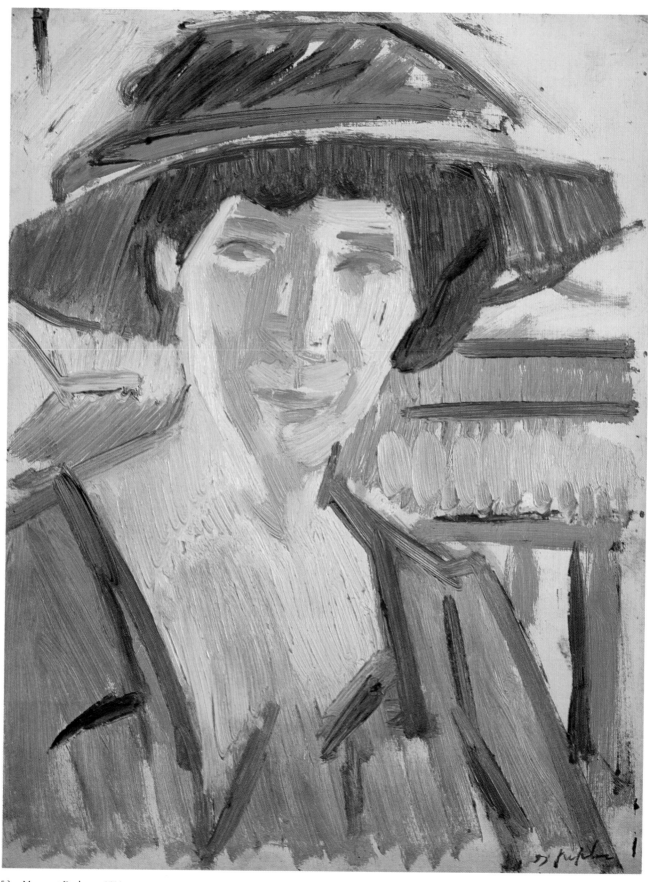

53 Margaret Peploe c. 1911

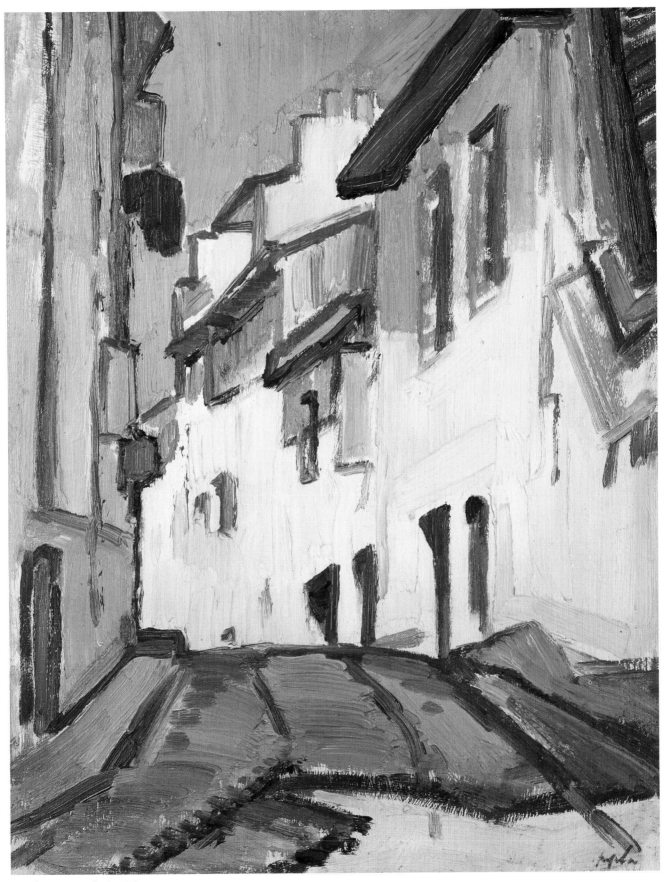

61 Street scene, Cassis *1913*

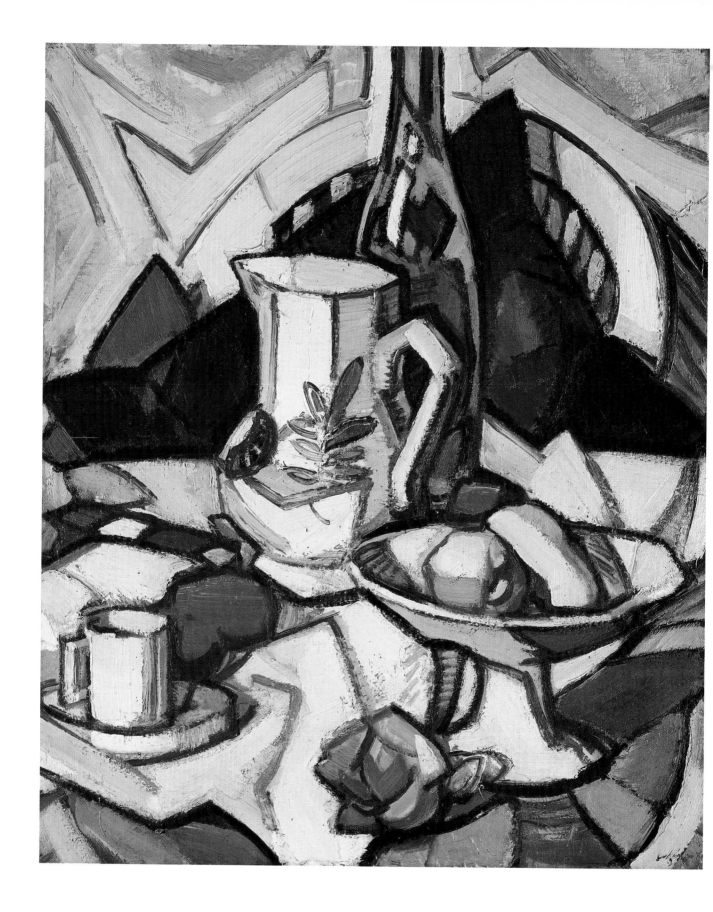

62 Still life *c. 1913*

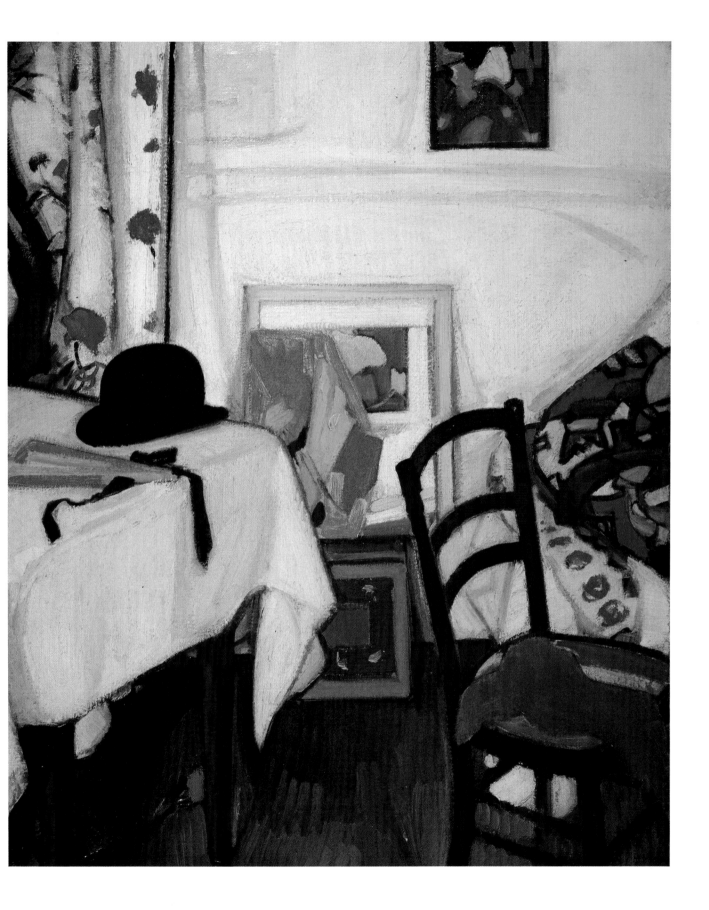

69 Interior with Japanese print *c. 1916*

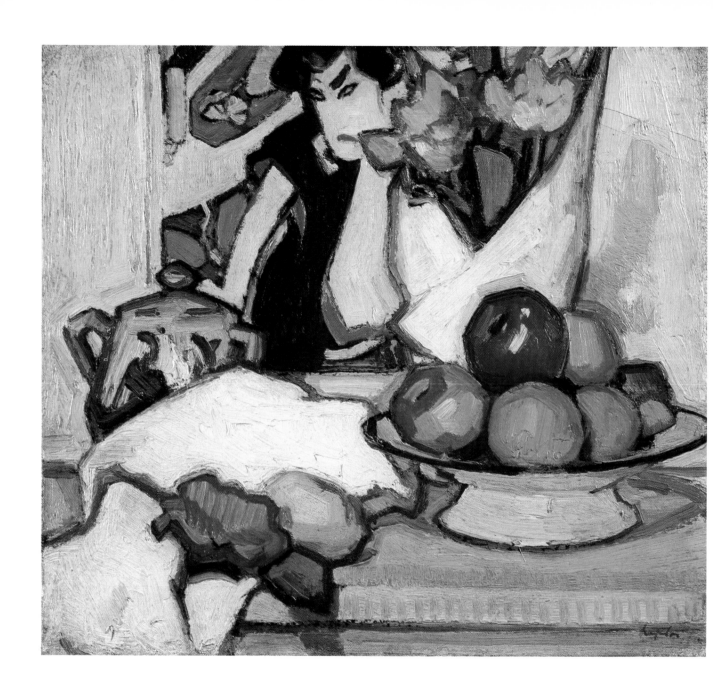

72 Flowers and fruit, Japanese background
c. 1916

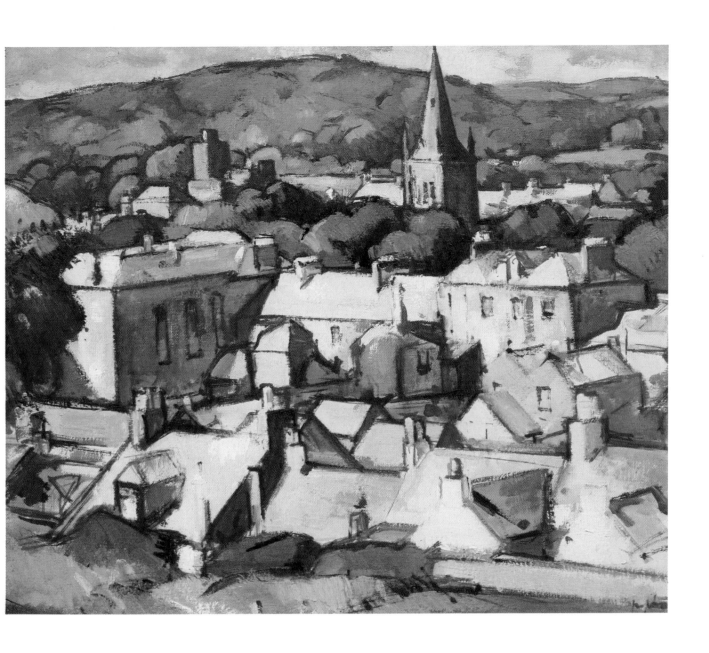

79 Kirkcudbright *c. 1919*

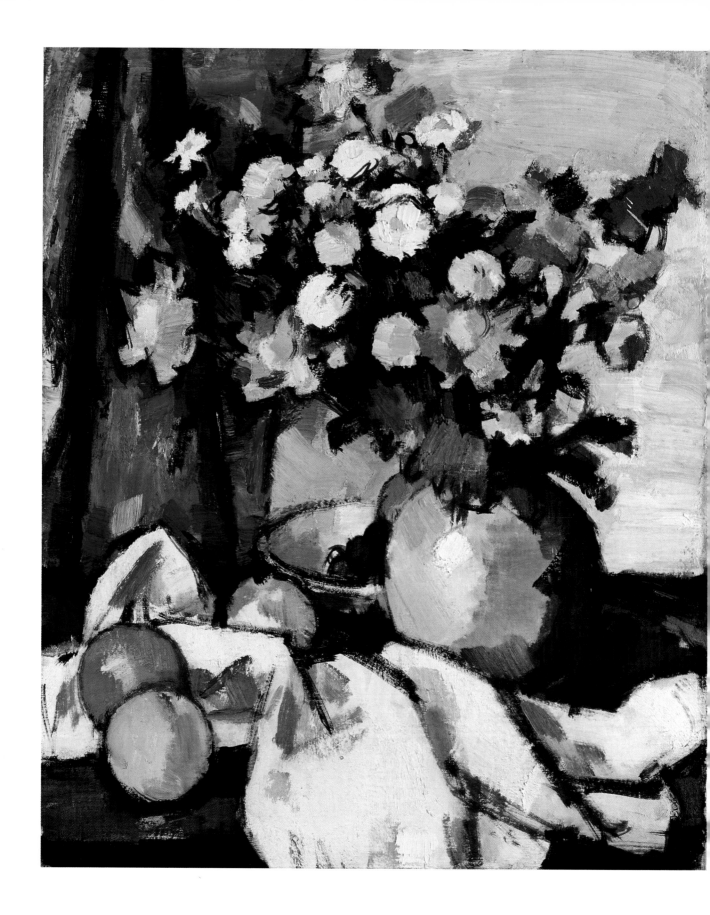

100 Michaelmas daisies and oranges *c. 1927*

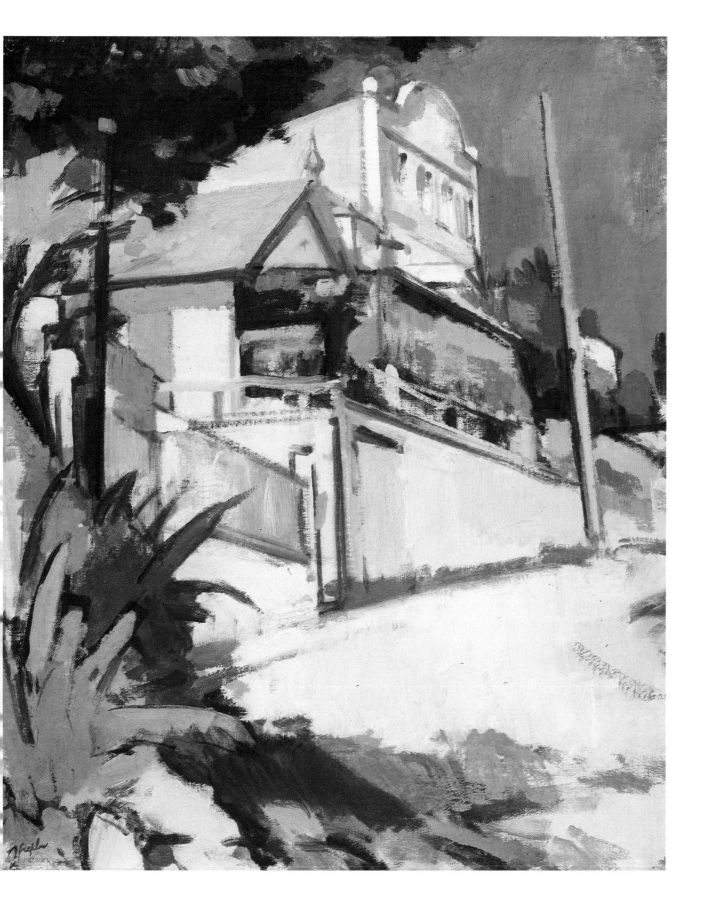

107 The aloe tree *1928*

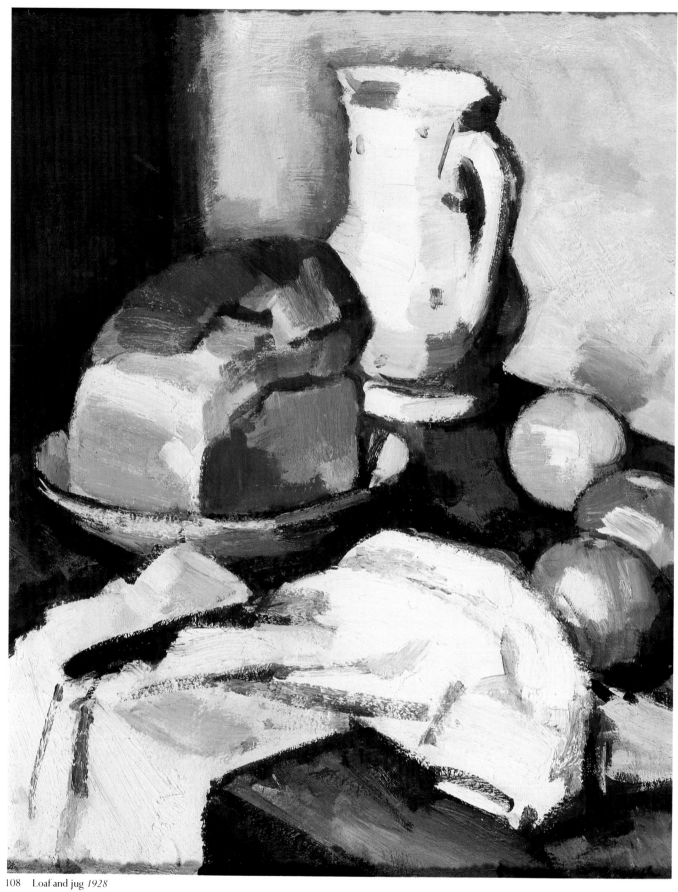

108 Loaf and jug *1928*

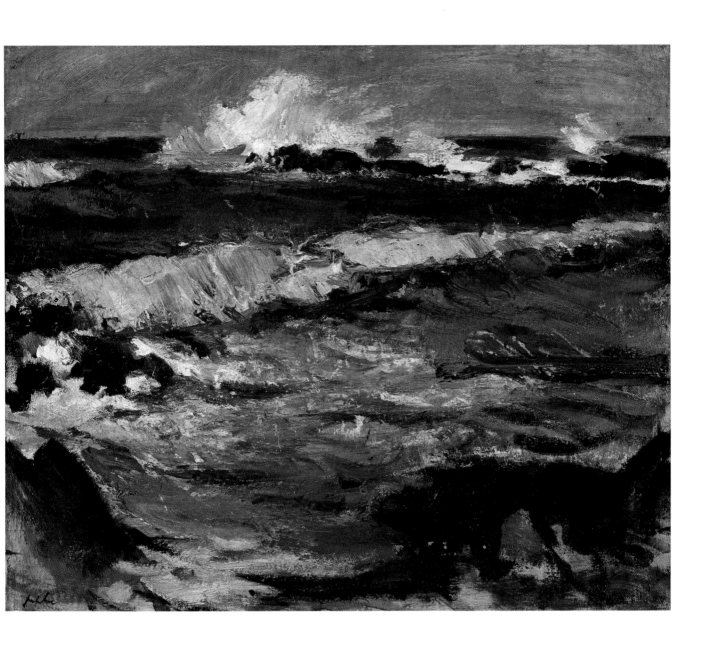

116 Stormy weather Iona *c. 1929*

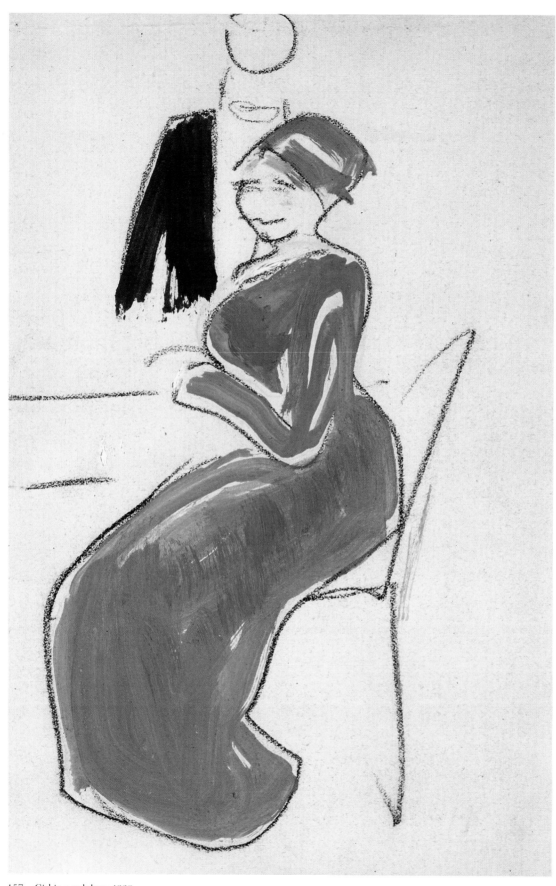

157 Girl in a red dress *1909*

S J PEPLOE CATALOGUE

Dimensions are given in centimetres, followed by inches in brackets — height preceding width.

Paintings

1 *Landscape* c. 1894
Oil on wood panel, 29.2 x 42.9 (11½ x 16⅞) Signed bottom left
Private collection
This is a unique early panel where Peploe confidently displays his understanding of Corot and the Barbizon School.

2 *Nude in studio interior* 1896
Oil on canvas, 91.4 x 71.1 (36 x 28)
Signed and dated top right: *SJP '96*
The Governors of Edinburgh College of Art
Painted in the life class at the Royal Scottish Academy in 1896, another study can be seen through the background drapery. The boyish form and pensive pose can be traced back to the Pre-Raphaelite Brotherhood.

3 *North Berwick sands* c. 1896
Oil on canvas, 38.1 x 31.8 (15 x 12¼)
Signed centre left: *peploe*
Kirkcaldy Art Gallery
Peploe began to visit North Berwick from about 1896 and this canvas dates from about then.

4 *Painting materials* c. 1897
Oil on canvas, 40.6 x 50.8 (16 x 20)
Signed bottom right: *peploe*
Private collection
This near monochromatic study is very much in keeping with still lifes by William Nicholson and the sombre compositions of his brother-in-law, James Pryde, who had left his native Edinburgh in 1890 for Paris and then London.

1 Landscape *c. 1894*

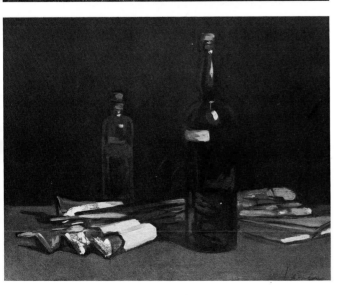

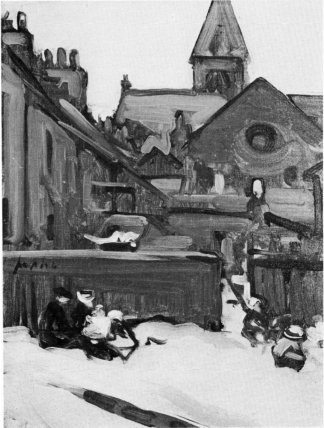

3 North Berwick sands *c. 1896*

4 Painting materials *c. 1897*

5 *Dish of roses* c. 1897
Oil on board, 25.1 x 35.2 (9⅞ x 13⅞)
Signed centre right: *peploe*
Private collection
A very early rose piece dating from the
time when Peploe had a studio in the
Albert Hall in Shandwick Place,
Edinburgh. The composition and the
technique show the influence of Manet
and Fantin-Latour.

6 *Studio interior* c. 1897
Oil on canvas, 60.8 x 61 (20 x 24)
Private collection
In this interior of his studio at
Shandwick Place, the central feature is
the 'Raeburn' chair, which often appears
in still lifes and is shown in a late studio
interior. This and other objects from the
artist's studio have been lent to the
exhibition (210).

7 *Dean village* c. 1898
Oil on board, 23.5 x 17.8 (9½ x 7)
Signed bottom right
The Hon. James Bruce

8 *Coffee and liqueur* c. 1898
Oil on canvas, 26.7 x 34.3 (10½ x 13½)
Signed vertically top left: *peploe*
The Burrell Collection, Glasgow
Museums and Art Galleries
Several pictures from this period are
signed vertically in the Japanese manner.

9 *Old Tom Morris* c. 1898
Oil on canvas, 127 x 101.6 (50 x 40)
Signed bottom right: *peploe*
Glasgow Art Gallery and Museum
This informal character study of Tom
Morris is Peploe's tribute to Hals and
Manet. Morris was a well-known
Edinburgh 'gentleman of the road'.

10 *Standing female nude* c. 1899
Oil on canvas, 91.4 x 61 (36 x 24)
Signed bottom right: *s j peploe*
Private collection
Compared to the life class study (2) the
technical bravura of this nude speaks
highly of the French painters Manet,
Degas and Toulouse-Lautrec.

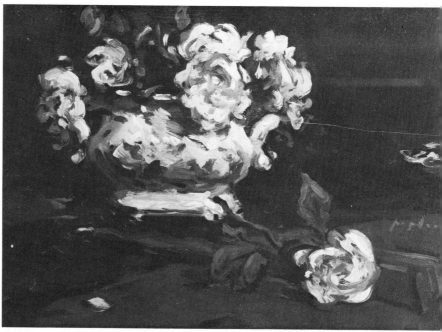

5 Dish of roses *c. 1897*

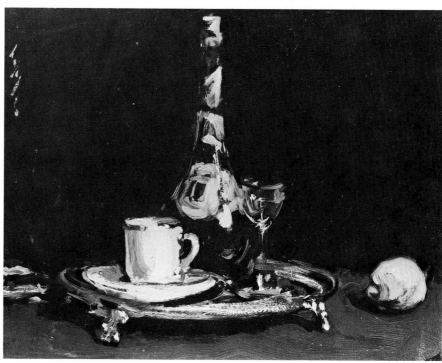

8 Coffee and liqueur *c. 1898*

11 *Girl reading* 1899
Oil on wood panel, 16.5 x 18.4
(6½ x 7¼)
Signed bottom right
Private collection

12 *Flowers, dark background* c. 1899
Oil on board, 31 x 26 (12¼ x 10¼)
Kirkcaldy Art Gallery

13 *Old man* 1900
Oil on canvas, 45.7 x 40.6 (18 x 16)
Signed centre right: *s j peploe*
Private collection
The strong influence of Daumier in this
early study shows Peploe's interest in the
realist tradition.

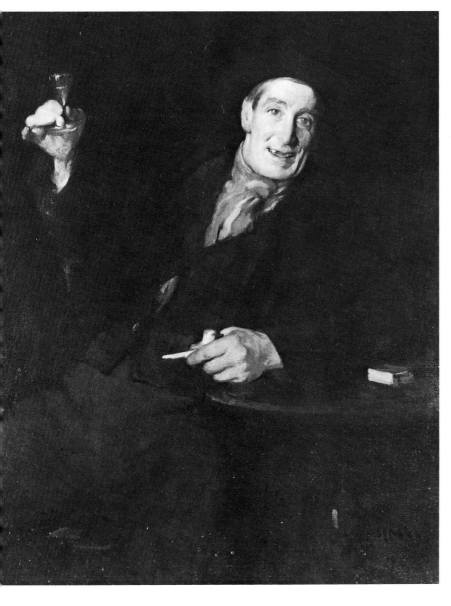

14 *Self portrait* c. 1900
Oil on wood panel, 50.8 x 30.5
(20 x 12)
Scottish National Gallery of
Modern Art
The piercing gaze and assured handling
of paint speak of professional self-
confidence but the artist gives nothing
of himself away. One can imagine him
employing his favourite conversational
put-down, "You think so?"

15 *Jeffrey's Brewery* c. 1900
Oil on wood panel, 15.2 x 22.8 (6 x 9)
Private collection
Thought to be one of the breweries by
Holyrood, Edinburgh.

16 *Self portrait* c. 1900
Oil on canvas, 50.8 x 40.6 (20 x 16)
Scottish National Portrait Gallery

17 *Head of a boy* 1901
Oil on canvas, 55.9 x 50.8 (22 x 20)
Private collection

18 *Man laughing (Portrait of Tom Morris)* c. 1902
Oil on board, 71.1 x 50.8 (28 x 20)
Scottish National Gallery of Modern Art
In contrast to the Glasgow portrait (9),
this is a real character study, painted
with a broader hand.

19 *Evening* c. 1902
Oil on wood panel, 17.4 x 25 (6⅞ x 9⅞)
Kirkcaldy Art Gallery
This was almost certainly painted on one
of his trips to North Berwick.

20 *Comrie, washerwoman* c. 1902
Oil on wood panel, 12.7 x 21.6 (5 x 8½)
Private collection

21 *Comrie, sheep,* c. 1902
Oil on wood panel, 12.7 x 20.9 (5 x 8¼)
Signed bottom left: *peploe*
Private collection

22 *Still life, shell* c. 1902
Oil on wood panel, 15.9 x 23.8
(6¼ x 9⅜)
Signed bottom right: *peploe*
Private collection

23 *Melon, grapes and apples, black back-
ground* c. 1902
Oil on canvas, 40.6 x 50.8 (16 x 20)
Signed bottom right: *peploe* and
vertically top left
Private collection

24 *Street in Comrie* c. 1902
Oil on canvas, 40.6 x 50.8 (16 x 20)
Signed bottom right: *peploe*
Private collection

25 *Barra* c. 1903
Oil on panel, 25 x 30 (9¾ x 11¾)
Signed: *S J Peploe* on back board
Kirkcaldy Art Gallery

26 *Spring, Comrie* c. 1903
Oil on canvas, 40.5 x 51 (16 x 20)
Signed bottom right: *peploe*
Kirkcaldy Art Gallery
Colour plate

27 *Still life — paint tubes* c. 1903
Oil on wood panel, 18.7 x 25.4
(7⅞ x 10)
Glasgow Art Gallery and Museum

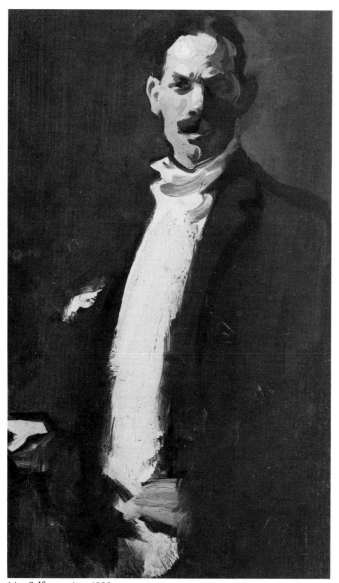

14 Self portrait *c. 1900*

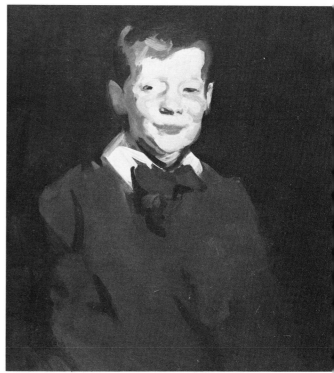

17 Head of a boy *1901*

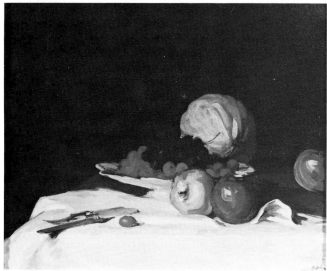

23 Melon, grapes and apples, black
 background *c. 1902*

18 Man laughing (portrait of Tom Morris)
 c. 1902

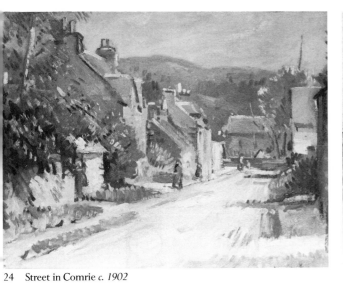

24 Street in Comrie *c. 1902*

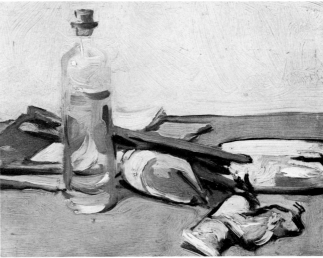

27 Still life — paint tubes *c. 1903*

28 *Souvenir (pewter jug, fan and oil sketch)* c. 1904
Oil on canvas, 33 x 43.2 (13 x 17)
Signed bottom right: *peploe*
Private collection
The real meaning of the title has been lost. It could refer to the panel depicting Comrie in the background.

29 *The black shawl* 1904
Oil on canvas, 50.8 x 40.6 (20 x 16)
Signed bottom right: *peploe*
Dundee Art Galleries and Museums
A portrait of Jeannie Blyth.

30 *The green blouse* c. 1904
Oil on wood panel, 50.8 x 50.2 (20 x 19¾)
Signed bottom left: *peploe*
Scottish National Gallery of Modern Art
Portrait of Jeannie Blyth executed perhaps ten years after his painting *Gipsy* (Private collection), but contemporary with *The black shawl* (29).

31 *Still life* c. 1904
Oil on wood panel, 26.7 x 34.3 (10½ x 13½)
City of Edinburgh Art Centre
The purchase of this work in 1907 by the Scottish Modern Arts Association who latterly presented it to Edinburgh, helped the growth of public interest in Peploe.

32 *Roses in blue vase, black background* c. 1904
Oil on canvas, 40.6 x 45.7 (16 x 18)
Private collection

33 *Beach scene, Brittany* c. 1905
Oil on wood panel, 16.5 x 23.5 (6½ x 9¼)
Private collection

34 *Still life, coffee pot* c. 1905
Oil on canvas, 61 x 82.5 (24 x 32½)
Signed bottom right
The Fine Art Society plc
Colour plate
This is one of the largest still lifes ever undertaken by Peploe and represents the height of his achievement in the years when he used a dark background.

35 *The black bottle* c. 1905
Oil on canvas, 50.8 x 61 (20 x 24)
Signed bottom left: *peploe*
Scottish National Gallery of Modern Art

36 *Mrs Peploe* c. 1906
Oil on canvas, 61 x 50.8 (24 x 20)
Signed bottom right: *peploe*
Private collection

37 *Game of tennis, Luxembourg Gardens* 1906
Oil on board, 15.5 x 23 (6⅛ x 9)
Scottish National Gallery of Modern Art

28 Souvenir (Pewter jug, fan and oil sketch) *c. 1904*

31 Still life *c. 1904*

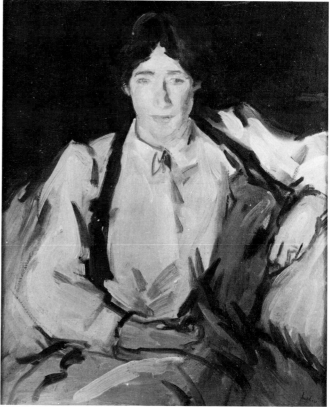

36 Mrs Peploe *c. 1906*

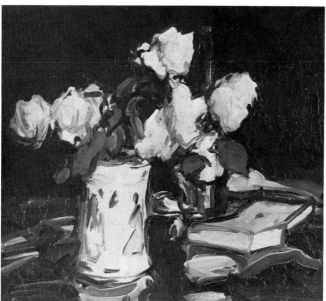

32 Roses in blue vase, black background
 c. 1904

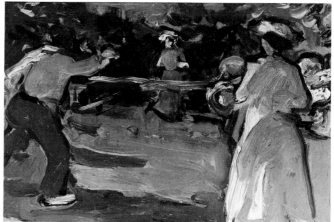

37 Game of tennis, Luxembourg Gardens
 1906

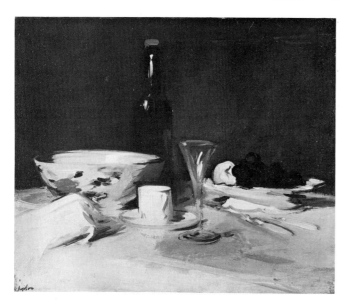

35 The black bottle *c. 1905*

38 *Lady in black* c. 1906
Oil on canvas, 61 x 40.7 (20 x 16)
Signed bottom left: *peploe*
Private collection
Monochromatic painting was popular at
the turn of the century. Compare, for
example, the work of Whistler, Sargent,
Nicholson and Pryde.

39 *Girl in pink* c. 1907
Oil on canvas, 45.7 x 40.7 (18 x 16)
Signed bottom right: *peploe*
Private collection
The blurred finish and fluid brushstrokes
are impressionistic in their attempt to
capture the energy of the restless girl.

40 *Plage scene* 1907
Oil on canvas board, 22.5 x 27
(8⅞ x 10⅝)
Kirkcaldy Art Gallery
Colour plate
This scene was probably painted on the
beach at Étaples. Like the impressionists
Peploe uses the colour and texture of
the unpainted board to render the
dresses of the two women in the
foreground.

41 *Edinburgh, view from Murrayfield
 golf course* c. 1907
Oil on panel, 16.2 x 23.8 (6⅜ x 9⅜)
Signed bottom left: *Peploe*
Private collection

42 *Interior with seated girl* c. 1908
Oil on canvas, 101.6 x 76.2 (40 x 30)
Signed bottom right: *peploe*
Private collection

43 *Beach scene, Paris Plage* c. 1908
Oil on panel, 24.8 x 31.4 (9¾ x 12⅜)
Private collection

44 *The white lady* c. 1908
Oil on canvas, 111.8 x 86.3 (44 x 34)
Signed bottom right: *S J Peploe*
Private collection

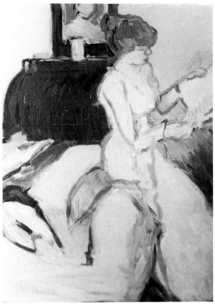

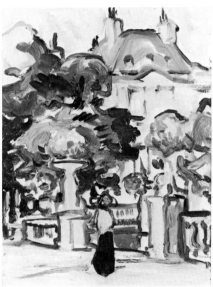

45 *Luxembourg Gardens* 1908
Oil on wood panel, 35.6 x 27.9 (14 x 11)
Signed centre left
Robert Fleming Holdings Ltd.
In 1931 Peploe presented this panel to
Flora Galbraith, née MacPhail, on her
wedding day. The MacPhail family lived
on Iona and were friendly with the
artist.

46 *The Luxembourg* c. 1908
Oil on wood panel, 24.1 x 20.3 (9½ x 8)
Private collection

47 Peggy Macrae *c. 1909*

45 Luxembourg Gardens *1908*

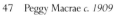

47 *Peggy Macrae* c. 1909
Oil on canvas, 61 x 52 (24 x 20½)
Signed lower left: *peploe*
Kirkcaldy Art Gallery
Peploe painted and drew Peggy Macrae
many times. The model was also popular
with other Edinburgh artists such as
Cadell and Charles Mackie

48 *Park scene* c. 1910
Oil on wood panel, 19 x 24 (7½ x 9½)
Kirkcaldy Art Gallery
This panel, painted with short dabs of
pure colour, is the farthest Peploe will
travel in this direction. Though small it
represents the peak and limit of ten

years of trying to render the atmospheric
qualities of landscape. From now on he
seems to seek for the underlying
structure of the subject rather than an
impression of its character.

49 *Verville Les Roses* c. 1910
Oil on board, 35.6 x 27 (14 x 10⅝)
Scottish National Gallery of Modern Art
Colour plate

50 *Boats at Royan* 1910
Oil on panel, 26.7 x 35.5 (10½ x 14)
Signed bottom left: *peploe*
Private collection
Painted on 29 August, the day Peploe's
first son, Willie, was born.

51 *Boats at Royan* 1910
Oil on board, 27 x 35.5 (10⅝ x 14)
Signed on reverse
Scottish National Gallery of Modern Art
Colour plate

52 *Jug and yellow fruit* c. 1911
Oil on wood panel, 33 x 41 (13 x 16⅛)
Signed lower left: *peploe*
Kirkcaldy Art Gallery
This work shows the powerful influence
not only of the fauve painters, but also of
their great forerunner Van Gogh.

53 *Margaret Peploe* c. 1911
Oil on card, 35.3 x 27 (13⅞ x 10⅝)
Signed bottom right: *S J Peploe*
Private collection
Colour plate
The daring use of green follows the
example of fauve portraits. Compare
Matisse's *The green line* and Derain's
Portrait of Matisse, both dated 1905. It
also pre-dates similar experiments by
Harold Gilman of the Camden Town
Group.

54 *Street scene, France* 1911
Oil on board, 34.2 x 26.6 (13½ x 10½)
Private collection
A preparatory drawing (170) shows how
the painting's structure was conceived
in terms of strong tonal contrasts.

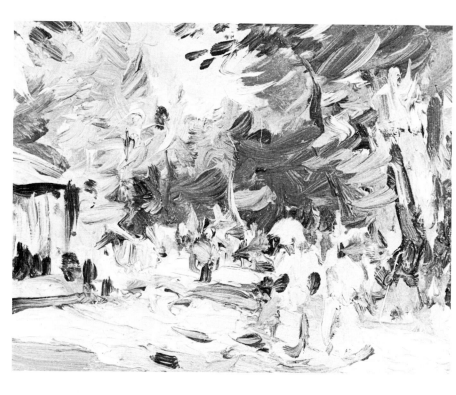

48 Park scene *c. 1910*

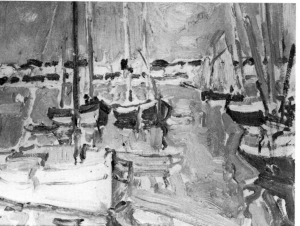

50 Boats at Royan *1910*

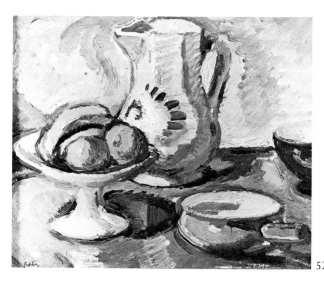

52 Jug and yellow fruit *c. 1911*

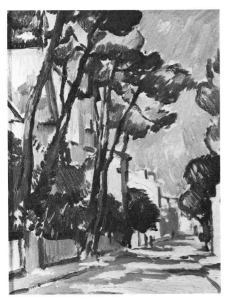

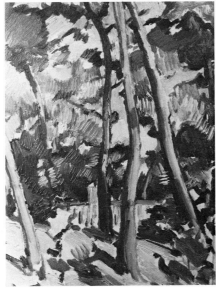

58 *Tulips in two vases, compotier, cup and saucer* 1912
Oil on canvas, 45.1 x 54.6 (17¾ x 21½)
Signed twice, bottom centre and right:
peploe
Private collection
Inscribed in ink on the frame:
S J Peploe, 278 Ble Raspail. A dramatic experiment in the style of Van Gogh who was greatly admired by the circle to which Peploe belonged in Paris.

59 *Roses* 1912
Oil on canvas, 50.8 x 55.9 (20 x 22)
Signed bottom left: *peploe*
Private collection

60 *Arran* 1913
Oil on board, 31.7 x 39.4 (12½ x 15½)
Signed: *peploe*
Private collection
Formerly known as *Comrie, landscape with hills*

61 *Street scene, Cassis* 1913
Oil on panel, 40 x 31.7 (15¾ x 12½)
Signed bottom right: *peploe*
J T R Ritchie
Colour plate

62 *Still life* c. 1913
Oil on canvas, 54.6 x 46.4 (21½ x 18¼)
Signed bottom right: *peploe*
Scottish National Gallery of Modern Art
Colour plate
Although described as 'cubistic' by the critic of *The Scotsman* when this work was first shown at the annual exhibition of the Society of Scottish Artists in 1913, the abstract patterning created by the strong outlines owes just as much to 'cloisonnisme' and the works of Auguste Chabaud (1882-1955).

63 *Anemones* c. 1914
Oil on canvas, 44.8 x 40 (17⅝ x 15¾)
Signed bottom right: *peploe*
J T R Ritchie

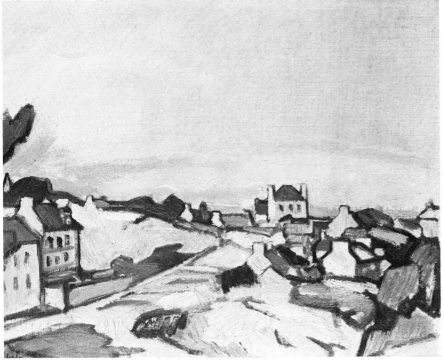

55 Île de Bréhat *1911*

55 *Île de Bréhat* 1911
Oil on board, 33.5 x 41.5
(13¼ x 16⅜)
Signed bottom left: *Peploe*
Scottish National Gallery of Modern Art
Île de Bréhat is a resort in Brittany. In this painting we see Cézanne's influence on Peploe's treatment of the landscape. There are also similarities with the landscapes Braque had been doing of L'Estaque in 1907.

56 *Île de Bréhat* 1911
Oil on wood panel, 33 x 40.6 (13 x16)
Signed bottom left: *peploe*
Inscribed on reverse: *To Tommy Honeyman and Cathy. With affection and appreciation*
Mr and Mrs Tim Honeyman

57 *The house in the woods* 1911
Oil on wood panel, 34.2 x 26.6
(13½ x 10½)
Private collection

41

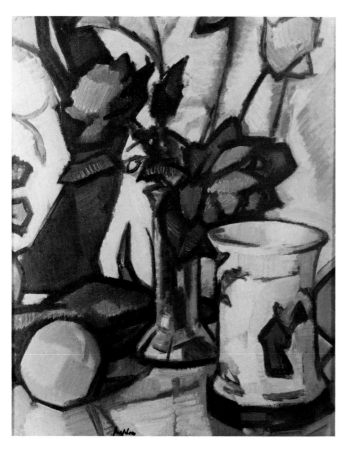

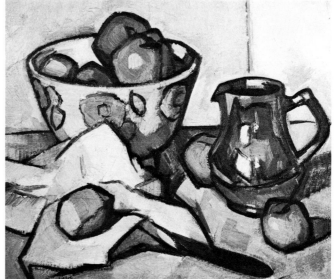

67 Still life c. 1915

66 Deep red roses and Chinese vase c. 1915

64 *Crawford* 1914
Oil on panel, 32.4 x 40.6 (12¾ x 16)
Signed bottom centre: *peploe* and dated
on reverse
Private collection
The village of Crawford is in
Dumfriesshire. The strong outlines and
bright primary colours make one think
of Brittany villages painted by the
followers of Gaugin.

65 *Benedictine bottle and fruit* c. 1914
Oil on canvas, 54.6 x 45.7 (21½ x 18)
Signed bottom right: *peploe*
Private collection

66 *Deep red roses and Chinese vase*
 c. 1915
Oil on panel, 40.6 x 33 (16 x 13)
Signed bottom centre: *peploe*
Private collection

67 *Still life* c. 1915
Oil on canvas, 45.7 x 54.6 (18 x 21½)
Signed bottom left: *peploe*
City Museum and Art Gallery, Stoke

68 *Portrait of a girl, red bandeau*
 c. 1915
Oil on canvas, 45.7 x 38.1 (18 x 15)
Signed bottom left: *peploe*
Private collection
The bright primary colours and
geometric composition of the head
recall similar contemporary work by J D
Ferguson. Peploe is still working on the
fauvist colour experiments that he had
begun in Paris about 1911.

69 *Interior with Japanese print* c. 1916
Oil on canvas, 80 x 64.2 (31½ x 25¼)
Signed bottom right: *peploe*
University of Hull Art Collection
Colour plate
The composition and subject are
reminiscent of Van Gogh's *Vincent's
bedroom, Arles* 1888. Comparison should
also be made with Cadell's paintings of
interiors. There is the same careful
placing of furniture and of bright colour
highlights, but, whereas Cadell's
interiors are elegant and polished
Edinburgh drawing rooms, Peploe's is
very much a working studio with props.

70. *Laggan Farm buildings, near
 Dalbeattie* c. 1916
Oil on panel, 31.7 x 38.1 (12½ x 15)
Signed bottom left: *peploe*
Glasgow Art Gallery and Museum

71 *Kirkcudbright Castle, reflections*
 c. 1916
Oil on panel, 31.7 x 39.4 (12½ x 15½)
Signed bottom right: *peploe*
Private collection
As in other Kirkcudbright panels of the
same period he is above all interested in
the geometry of the buildings.

72 *Flowers and fruit, Japanese background*
 c. 1916
Oil on canvas, 40.5 x 45.5 (16 x 18)
Signed bottom right: *peploe*
Kirkcaldy Art Gallery
Colour plate
Japanese prints feature in several still
lifes. Peploe appreciated their formal
and decorative strength.

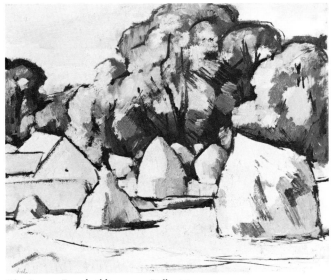

70 Laggan Farm buildings, near Dalbeattie

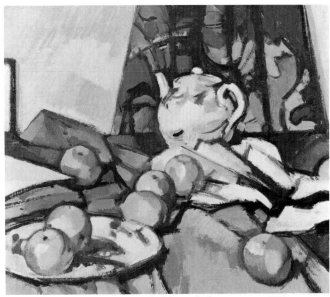

74 The blue and white teapot *c. 1917*

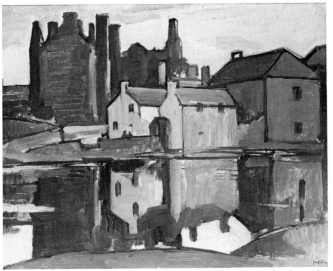

71 Kirkcudbright castle, reflections *c. 1916*

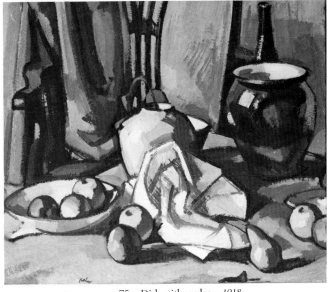

75 Dish with apples *c. 1918*

73 *Still life, three carnations* c. 1916
Oil on canvas, 45.7 x 55.9 (18 x 22)
Private collection

74 *The blue and white teapot* c. 1917
Oil on canvas, 48 x 57 (18⅞ x 22⅜)
Signed lower left: *peploe*
Kirkcaldy Art Gallery

75 *Dish with apples, ginger jar, brown crock, bottle and chair* c. 1918
Oil on canvas, 63.5 x 76.2 (25 x 30)
Signed bottom centre left: *peploe*
Private collection
This painting looks forward to the kind of classicism which Peploe developed in the late twenties.

76 *Still life* c. 1918
Oil on canvas, 64 x 77 (25¼ x 30¼)
The Maclean Museum and Art Gallery, Greenock

77 *Tulips, the blue jug* c. 1918
Oil on canvas, 45.7 x 55.9 (18 x 22)
Signed bottom right: *peploe*
Private collection

78 *Still life: tulips with black blackground* c. 1918
Oil on canvas, 50.2 x 49.5 (19¾ x 19½)
Signed bottom left: *peploe*
Mr and Mrs John B Rankin

79 *Kirkcudbright* c. 1919
Oil on canvas, 55.9 x 63.5 (22 x 25)
Robert Fleming Holdings Ltd.
Colour plate

80 *Cathedral Rock, Iona* 1920
Oil on panel, 38.1 x 45.7 (15 x 18)
Signed bottom centre right: *peploe*
Private collection
This picture was painted on his first visit to Iona. The 'Cathedral Rock' is one of the most distinctive forms on the North end of the island.

81 *Still life, pink roses* c. 1920
Oil on canvas, 50.9 x 40.7 (20 x 16)
Signed bottom left: *peploe*
Glasgow Art Gallery and Museum
There are stylistic indications that this
work is a late attempt to paint a rose
piece in his old manner, when he
occupied a studio at 6 Devon Place
from 1900-1905.

82 *Roses and still life* c. 1920
Oil on canvas, 73.7 x 50.9 (29 x 20)
Signed bottom right: *peploe*
Private collection
This is one of a group of pictures in
which Peploe used a dry, dense paint
and acid colours; in which objects are
stacked up in an unreal space. They look
back to the still lifes of c. 1914 (but
without the black outlines), rather than
to the monumental compositions of his
maturity.

83 *Still life with melon* c. 1919-20
Oil on canvas, 46 x 40.5 (18⅛ x 16)
Signed bottom left: *s j peploe*
Scottish National Gallery of Modern Art

84 *Roses* c. 1921
Oil on canvas, 50.8 x 61 (20 x 24)
Signed bottom centre: *peploe*
Scottish National Gallery of Modern Art
Peploe continues to demonstrate his
interest in schematic colour design in
this work which is dominated by the
yellow tablecloth.

80 Cathedral Rock,
Iona *1920*

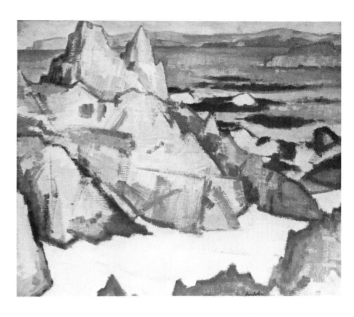

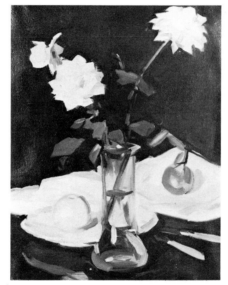

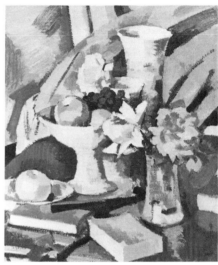

82 Roses and still life *c. 1920*

81 Still life, pink roses
c. 1920

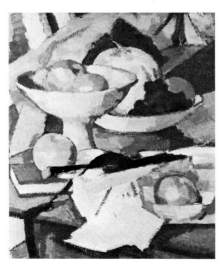

83 Still life with
melon *c. 1919-20*

84 Roses *c. 1921*

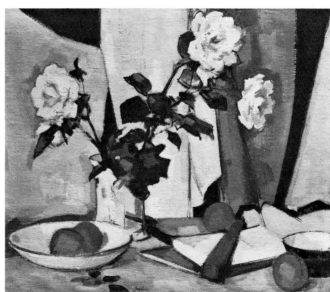

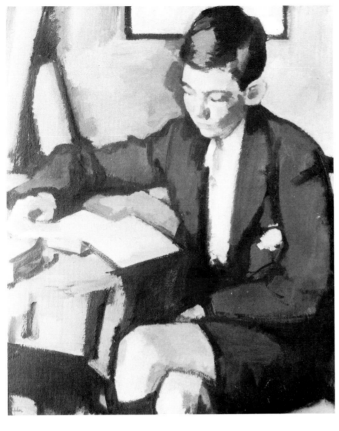

85 Boy reading *1921*

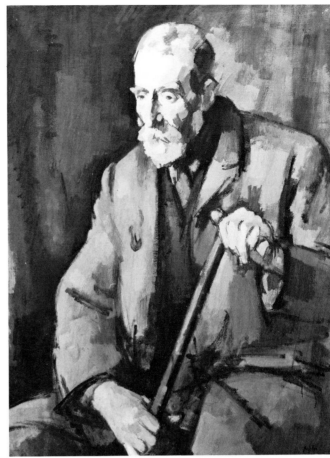

86 Old Duff *1922*

85 *Boy reading* 1921
Oil on canvas, 63.5 x 76.2 (25 x 30)
The Royal Scottish Academy
This is the artist's son, Willie Peploe,
in his Edinburgh Academy uniform,
aged approximately eleven, thus dating
the work to 1921. It entered the
collection of the Royal Scottish
Academy in 1927 as his diploma work.

86 *Old Duff* 1922
Oil on canvas, 101.6 x 76.2 (40 x 30)
Signed bottom right: *peploe*
Glasgow Art Gallery and Museum
The use of dry paint and strong light is
a marked contrast to Peploe's early
portraits. Peploe's great exemplar is now
Cézanne rather than Hals or Manet.

87 *Roses in Chinese vase* c. 1922
Oil on canvas, 50.8 x 40.6 (20 x 16)
Signed bottom left
Mr and Mrs Clark Hunter

88 *Roses* c. 1922
Oil on canvas, 50.8 x 40.6 (20 x 16)
Signed bottom left: *peploe*
J T R Ritchie

89 *Morar* 1923
Oil on wood panel, 45.7 x 40.6 (18 x 16)
J T R Ritchie

90 *Still life with roses* c. 1924
Oil on canvas, 50.8 x 40.6 (20 x 16)
Signed bottom right: *peploe*
Aberdeen Art Gallery and Museums

91 *Roses* c. 1924
Oil on canvas, 50.8 x 40.6 (20 x 16)
Signed bottom left: *peploe*
Private collection
Roses is an expanded version of (90)

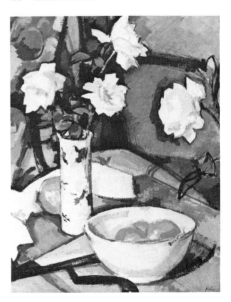

90 Still life with roses *c. 1924*

92 *Landscape at Cassis* 1924
Oil on canvas, 57.2 x 45.8 (22½ x 18)
Signed bottom right: *peploe*
Scottish National Gallery of Modern Art

93 *Landscape, South of France* 1924
Oil on canvas, 50.8 x 55.9 (20 x 22)
Signed bottom right: *peploe*
Scottish National Gallery of Modern Art

94 *The brown crock* c. 1925
Oil on canvas, 61 x 50.8 (24 x 20)
Signed top left: *peploe*
Glasgow Art Gallery and Museum

95 *Summer (New Abbey, Dumfriesshire)*
1925
Oil on canvas, 56.4 x 76.5 (22¼ x 30⅛)
Signed bottom left: *s j peploe*
Hunterian Art Gallery, University of
Glasgow
At this time Peploe began to show a
greater breadth and vigour of handling
in his landscapes.

96 *Still life, white roses* 1925
Oil on canvas, 45.8 x 40.6 (18 x 16)
Signed bottom left: *peploe*
Glasgow Art Gallery and Museum

97 *Ben More from Iona* c. 1925
Oil on canvas, 63.5 x 76.5 (25 x 30⅛)
Signed bottom left: *peploe*
Hunterian Art Gallery, University of
Glasgow

98 *Tulips* 1926
Oil on canvas, 55.9 x 50.8 (22 x 20)
Signed bottom right
Private collection

99 *Aspidistra* c. 1927
Oil on canvas, 61 x 50.8 (24 x 20)
Signed bottom left
Private collection

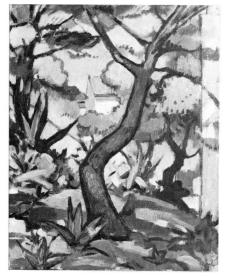
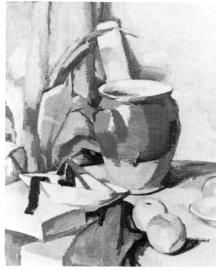

92 Landscape at Cassis *1924* 94 The brown crock *c. 1925*

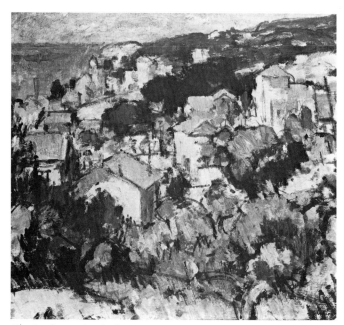

93 Landscape, South of France *1924*

95 Summer (New Abbey, Dumfriesshire) *1925*

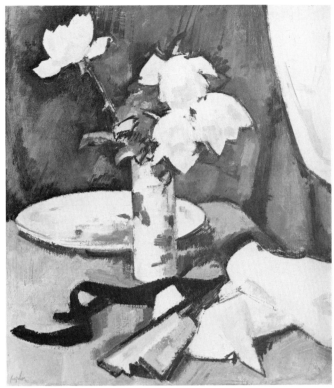

96 Still life, white roses *1925*

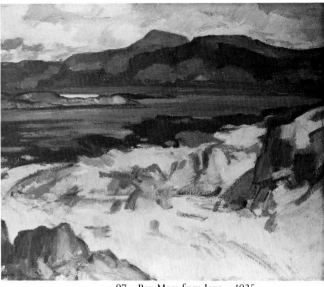

97 Ben More from Iona *c. 1925*

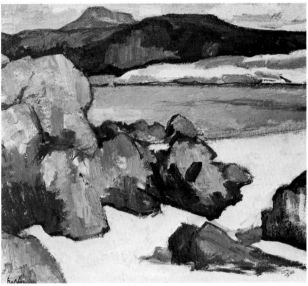

101 Iona landscape, rocks *c. 1927*

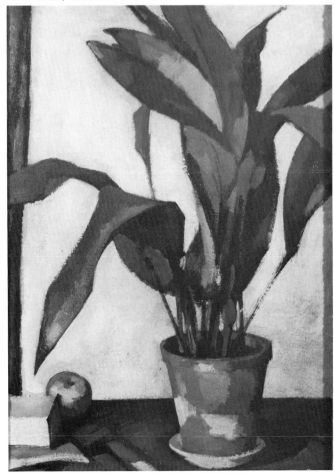

99 Aspidistra *c. 1927*

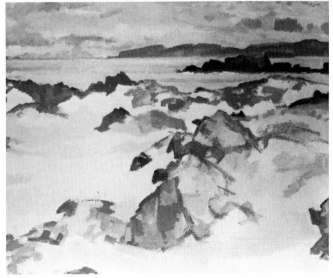

102 Grey day, Iona *c. 1927*

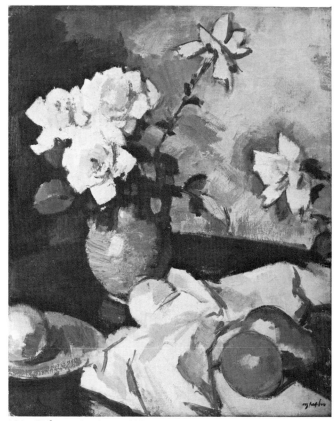

104 Pink roses in a jug *c. 1928*

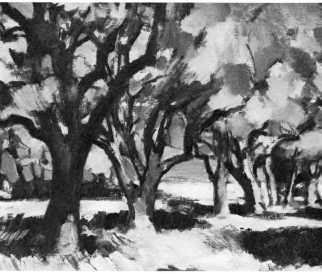

106 Trees, Antibes *1928*

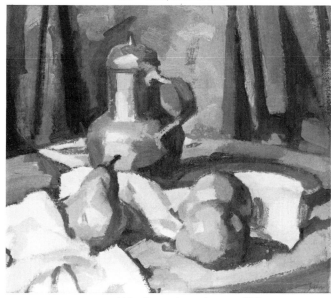

110 Pewter jug and pears *c. 1928*

100 *Michaelmas daisies and oranges*
 c. 1927
Oil on canvas, 61 x 50.8 (24 x 20)
Signed bottom left
Private collection
Colour plate

101 *Iona landscape, rocks* c. 1927
Oil on canvas, 39.7 x 46 (15⅝ x 18⅛)
Signed bottom left: *peploe*
Scottish National Gallery of Modern Art

102 *Grey day, Iona* c. 1927
Oil on canvas, 50.8 x 61 (20 x 24)
Signed bottom left: *S J Peploe*
Private collection

103 *Roses in a brown jar* c. 1928
Oil on canvas, 45.8 x 40.6 (18 x 16)
Private collection

104 *Pink roses in a jug* c. 1928
Oil on canvas, 55.9 x 45.7 (22 x 18)
Signed bottom right: *s j peploe*
Private collection

105 *Palm trees, Antibes* 1928
Oil on canvas, 61 x 50.8 (24 x 20)
Signed bottom right: *peploe*
Kirkcaldy Art Gallery
Cover illustration

106 *Trees, Antibes* 1928
Oil on canvas, 63.5 x 76.2 (25 x 30)
Signed bottom right: *peploe*
Private collection

107 *The aloe tree* 1928
Oil on canvas, 61 x 50.8 (24 x 20)
Signed bottom left: *s j peploe*
Manchester City Art Galleries
Colour plate
The central building is the Hôtel
Panorama, Cassis, where Peploe stayed.

108 *Loaf and jug* 1928
Oil on canvas, 50.8 x 40.6 (20 x 16)
Signed bottom right: *s j peploe*
Private collection
Colour plate

109 *The Pink House, Cassis*
 1928
Oil on canvas, 61 x 50.8 (24 x 20)
Private collection

110 *Pewter jug and pears* c. 1928
 (verso: *Landscape study*)
Oil on canvas, 40.6 x 45.8 (16 x 18)
Signed bottom right: *peploe*
Private collection

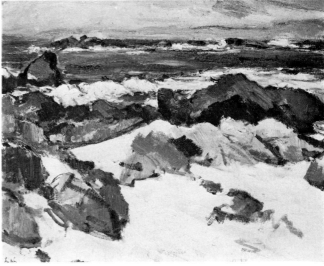

117 A rocky shore, Iona *c. 1929*

111 Sweetheart Abbey *1928*

114 Buddha *c. 1929*

115 The artist's studio *1929*

111 *Sweetheart Abbey* 1928
Oil on canvas, 50.8 x 61 (20 x 24)
Signed bottom left: *s j peploe*
Kirkcaldy Art Gallery

112 *Summer day, Iona* 1928
Oil on canvas, 50.8 x 61 (20 x 24)
Mr and Mrs Clark Hunter

113 *White sands Iona, view of Ben More*
c. 1929
Oil on canvas, 50.8 x 61 (20 x 24)
Private collection

114 *Buddha* c. 1929
Oil on canvas, 55.9 x 50.8 (22 x 20)
Signed bottom right
Private collection
This small marble Buddha was also
painted several times by F C B Cadell.

115 *The artist's studio* 1929
Oil on canvas, 76.2 x 63.5 (30 x 25)
Signed bottom left: *s j peploe*
Private collection
This is Peploe's studio in Shandwick
Place containing the chair which
features in many of the artist's still life
studies.

116 *Stormy weather, Iona* c. 1929
Oil on canvas, 50.8 x 61 (20 x 24)
Signed bottom left: *peploe*
Aberdeen Art Gallery and Museums
Colour plate
The concentration on the sea as sole
subject recalls MacTaggart in this and
other later Iona works. There is some

sand mixed in with the paint, probably
blown on to the canvas by the force of
the wind.

117 *A rocky shore, Iona* c. 1929
Oil on canvas, 40.7 x 50.5 (16 x 19⅞)
Signed bottom left: *peploe*
City of Edinburgh Art Centre
Peploe painted these Iona studies
outside, enjoying the power of the
elements.

118 *The old fiddle* c. 1929
Oil on canvas, 50.8 x 71.1 (20 x 28)
Private collection
A fiddle, a hat and a pewter jug might
seem a contrived choice for a still life,
but they are so aptly incorporated into
the design, that their juxtaposition
actually takes on a strange significance.

119 *Chops* c. 1930
Oil on canvas, 44.5 x 39.3 (17½ x 15½)
Signed bottom left: *peploe*
Private collection
In this and (118) Peploe paints a mono-
chromatic still life with a warm toned
splash of interest in the fiddle and chops.

120 *Nude in interior with guitar*
c. 1930
Oil on canvas, 101.6 x 76.2 (40 x 30)
Signed bottom right
The Fine Art Society, Glasgow
Peploe painted a series of nudes in the
late twenties and early thirties, this one
being a particularly elaborate pose.

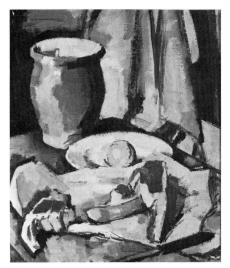

119 Chops *c. 1930*

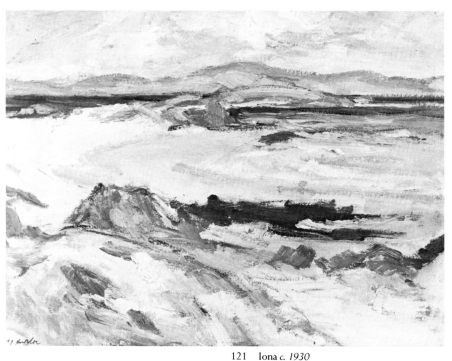

121 Iona *c. 1930*

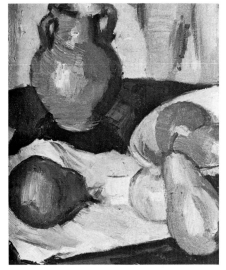

122 The green jar

124 A still life of roses *c. 1931*

125 Still life with plaster cast *c. 1931*

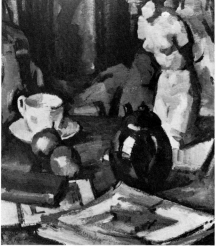

121 *Iona* c. 1930
Oil on panel, 50 x 71 (19½ x 27¾)
Signed bottom left: *S J Peploe*
Kirkcaldy Art Gallery

122 *The green jar* c. 1930
Oil on canvas, 35.5 x 30.5 (14 x 12)
Kirkcaldy Art Gallery

123 *Still life with roses and green grapes*
 c. 1930
Oil on canvas, 43.2 x 39.3 (17 x 15½)
Signed bottom left: *Peploe*
The University of Edinburgh

124 *A still life of roses* c. 1931
Oil on canvas, 45.7 x 40.6 (18 x 16)
Signed bottom left: *peploe*
Perth Museum and Art Gallery

125 *Still life with plaster cast* c. 1931
Oil on canvas, 58.4 x 54.6 (23 x 21½)
Signed bottom left: *peploe*
Scottish National Gallery of Modern Art

126 *Still life, fruit* c. 1931
Oil on canvas, 51 x 61.5 (20⅛ x 24¼)
Signed bottom right: *peploe*
Kirkcaldy Art Gallery

127 *Still life* c. 1931
Oil on canvas, 50.8 x 55.9 (20 x 22)
Signed bottom right: *s j peploe*
Robert Fleming Holdings Ltd.

128 *Still life with fruit* c. 1932
Oil on canvas, 50.8 x 55.9 (20 x 22)
Signed bottom right
Gracefield Arts Centre, Dumfries
The composition and use of colour in
this heavily re-worked still life seems to
look forward to Sir William Gillies.

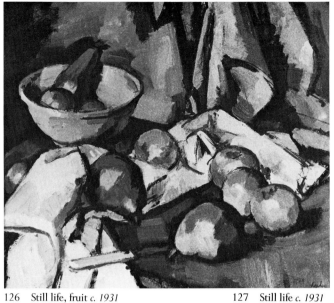

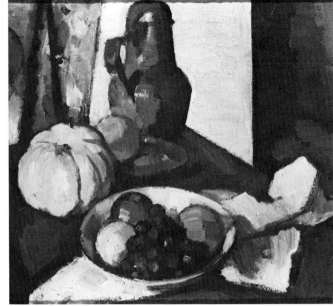

126 Still life, fruit *c. 1931* 127 Still life *c. 1931*

129 *Perthshire landscape* 1933
Oil on canvas, 53.3 x 68.5 (21 x 27)
Signed bottom right
Private collection

130 *Roses in a grey jar* c. 1933
Oil on canvas, 50.8 x 40.6 (20 x 16)
Signed bottom left: *Peploe*
Scottish National Gallery of Modern Art

131 *Perthshire landscape* 1934
Oil on canvas, 50.8 x 66 (20 x 26)
Robert Fleming Holdings Ltd.
Painted near Calvine.

132 *Rothiemurchus* 1934
Oil on canvas, 40.6 x 45.7 (16 x 18)
Signed bottom left
Private collection
This is held to be the last work Peploe
painted from nature.

133 *Tulips in a brown jar* c. 1934
Oil on canvas, 45.7 x 40.6 (18 x 16)
Signed bottom left: *peploe*
Private collection

134 *Tulips* 1934
Oil on canvas, 45.7 x 40.6 (18 x 16)
Signed bottom right
Private collection
This is thought to be the last picture
painted by Peploe.

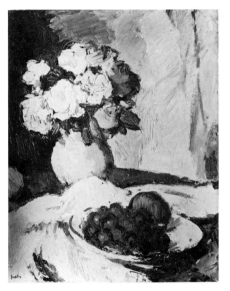

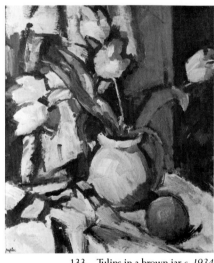

133 Tulips in a brown jar *c. 1934*

130 Roses in a grey jar *c. 1933*

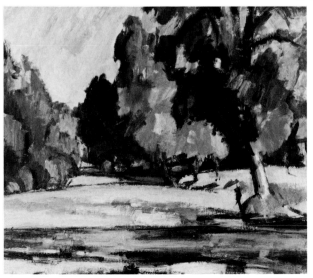

131 Perthshire landscape
1934

Drawings

135 *Boy in knickerbockers* c. 1893
Monochrome watercolour on paper,
25.4 x 17.8 (10 x 7)
Private collection

136 *Girl with clasped hands* 1893
Monochrome watercolour on paper,
25.4 x 17.8 (10 x 7)
Inscribed: *Aug 1893*
Private collection

137 *Head of Tom Morris,* c. 1896
Charcoal on paper, 34.3 x 26.7
(13½ x 10½)
Signed bottom right
Private collection

138 *Full length self portrait at easel*
c. 1898
Charcoal on paper, 47.6 x 32.4
(18¾ x 12¾)
Signed bottom left
Private collection

139 *Head and shoulders of a woman*
1904
Black conté on paper, 35.5 x 25.4
(14 x 10)
Signed bottom left
Private collection

140 *Head of a young girl* 1905
Pastel on paper, 31.5 x 24.5 (12⅜ x 9⅝)
Signed lower left
Scottish National Gallery of Modern Art

141 *Figure of a woman* 1905
Indian ink and red chalk on paper,
27.9 x 17.1 (11 x 6¾)
Private collection

142 *Head of J D Fergusson* 1906
Black conté on paper, 20.3 x 11.7
(8 x 4⅞)
Signed bottom left
Private collection

143 *Head of Margaret Peploe* 1906
Black ink and sanguine on paper,
27.6 x 22.2 (10⅞ x 8¾)
Signed bottom right
Private collection

144 *J D Fergusson* 1907
Black conté on paper, 22.8 x 14 (9 x 5½)
Signed bottom right
Private collection

145 *Girl feeding hens* 1907
Charcoal and pastel on sepia paper,
35.5 x 25 (14 x 9⅞)
Signed lower centre right
Gracefield Arts Centre, Dumfries

146 *Man and child* 1907
India ink on paper, 14 x 20.9 (5½ x 8¼)
Private collection

147 *Woman leaning back* 1907
Black conté on paper, 27.9 x 20.9
(11 x 8¼)
Signed bottom left
Private collection

137 Head of Tom Morris *c. 1896*
140 Head of a young girl *1905*

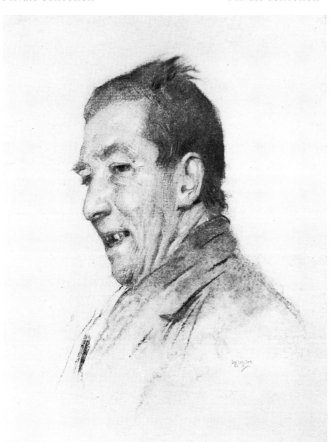

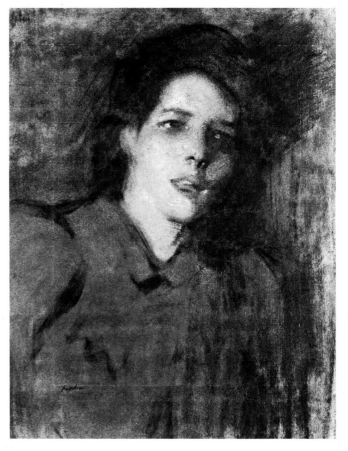

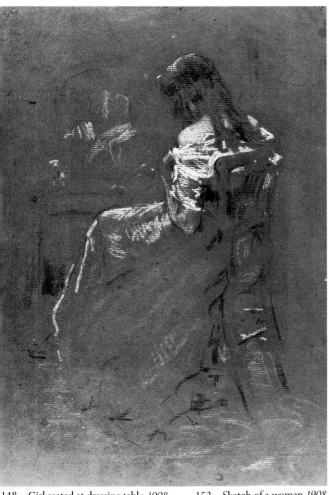

148 Girl seated at dressing table *1908* 152 Sketch of a woman *1908*

148 *Girl seated at dressing table* 1908
Charcoal and pastel on sepia paper,
41.9 x 29.2 (16½ x 11½)
Inscribed and dated on reverse
Hunterian Art Gallery, University of
Glasgow

149 *Head of a girl* 1908
Sanguine on paper, 27.6 x 21.2
(10⅞ x 8⅜)
Signed bottom right
Private collection

150 *Head of a girl, Peggy Macrae* 1908
Sanguine on paper, 27.9 x 22.2 (11 x 8¾)
Signed bottom centre
Private collection

151 *Head and shoulders of a woman*
 1908
Black conté on paper, 20.3 x 17.4
(8 x 6⅞)
Signed bottom right
Private collection

152 *Sketch of a woman* 1908
Pencil on paper, 27.6 x 18.4 (10⅞ x 7¼)
Signed bottom left
Glasgow Art Gallery and Museum

153 *Boats and houses* 1909
Black conté and ink on paper, 9 x 11.4
(3½ x 4½)
Private collection

154 *Female figure* 1909
Sanguine on paper, 26.7 x 22.5
(10½ x 8⅞)
Signed bottom right
Private collection

155 *Figures in street* 1909
Black conté and oil on paper,
23.5 x 22.8 (9¼ x 9)
Signed bottom right
Private collection

156 *Fish market* 1909
Pastel on paper, 32 x 47 (12½ x 18½)
Signed bottom left: *Peploe*
Kirkcaldy Art Gallery

157 *Girl in red dress* 1909
Black conté and oil on paper,
21.6 x 14 (8½ x 5½)
Private collection
Colour plate

158 *Head* 1909
Conté on paper, 21 x 12.4 (8¼ x 4⅞)
Signed bottom right
Private collection

159 *Self portrait* 1909
Ink on paper, 24.7 x 17.1 (9¾ x 6¾)
Private collection

160 *Baby crawling* 1910
Oil and conté on paper, 22.2 x 15.2
(8¾ x 6)
Signed bottom left
Private collection

161 *Baby's head* 1910
Signed bottom right
Private collection

162 *The flower market* 1910
Black conté and oil on paper,
9.5 x 17.7 (3¾ x 7)
Signed bottom right
The Hon. James Bruce

163 *Head of man with beard* 1910
Black conté on paper,
17.5 x 22.2 (6⅞ x 8¾)
Signed bottom right
Private collection

164 *Montmartre* 1910
Pencil on paper, 21.6 x 12.7 (8½ x 5)
Private collection

165 *Mother and child* 1910
Black conté and oil on paper,
20.9 x 15.2 (8¼ x 6)
The Hon. James Bruce
This is a portrait of the artist's wife
Margaret and their first child, Willie.

166 *Olympia Bar* 1910
Pencil on paper, 21.6 x 12.7 (8½ x 5)
Private collection

167 *Panthéon* 1910
Pencil on paper, 21.6 x 12.7 (8½ x 5)
Private collection

168 *Police patrol* 1910
Black conté and oil on paper,
13.9 x 21.6 (5½ x 8½)
Signed bottom left
The Hon. James Bruce

169 *St Honoré* 1910
Pencil on paper, 21.6 x 12.7 (8½ x 5)
Private collection

170 *Street scene, trees* 1910
Black ink on paper, 12.1 x 8.9 (4¾ x 3½)
Private collection
This is a study for (54).

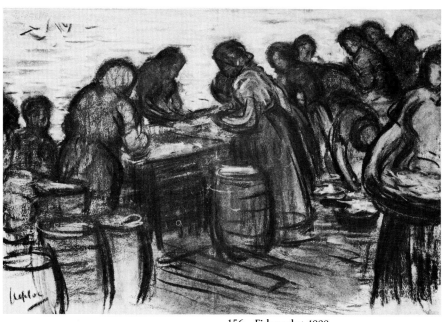

156 Fish market *1909*

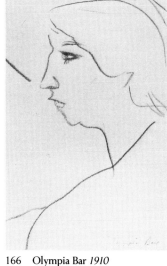

164 Montmartre *1910*

166 Olympia Bar *1910*

167 Panthéon *1910*

169 St Honoré *1910*

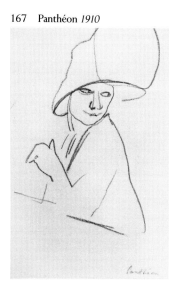

170 Street scene, trees *1910*

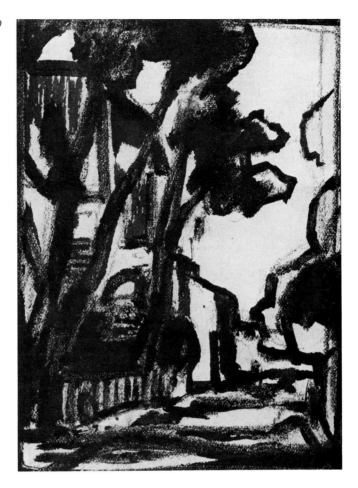

171 *Study of a child* 1910
Black conté and oil on paper,
13.9 x 11.4 (5½ x 4½)
Signed bottom left
The Hon. James Bruce

172 *Girl with head in hands* 1911
Black conté and oil on paper,
22.2 x 17.5 (8¾ x 6⅞)
Signed bottom right
Private collection

173 *Mother with baby* 1911
Black conté on paper, 22.2 x 15.2
(8¾ x 6)
Signed bottom centre
Private collection

174 *Design, abstract* 1912
Oil on paper, 16.5 x 12 (6½ x 4¾)
Private collection

175 *Design, female nude* 1912
Oil on paper, 14.6 x 11.7 (5¾ x 4⅝)
Private collection

176 *Design, figures* 1912
Black conté and ink on paper,
8.8 x 8.2 (3½ x 3¼)
Private collection

177 *Man and woman in café* 1912
Black conté on paper,
22.2 x 17.5 (8¾ x 6⅞)
Signed bottom right
Private collection

178 *Mother and baby reclining* 1912
Black conté on paper, 15.2 x 22.2
(6 x 8¾)
Signed bottom left
Private collection

179 *Cassis square* 1913
Black conté on paper, 17.5 x 22.2
(6⅞ x 8¾)
Signed bottom right
Private collection

180 *Child's head* 1913
Black conté and oil on paper,
22.8 x 15.2 (9 x 6)
Private collection

181 *Landscape with houses* 1913
Black conté and ink, 14.6 x 16.8
(5¾ x 6⅝)
Private collection

182 *Moustique "la Peur"* 1913
Black conté on paper, 24.1 x 15.2
(9½ x 6)
Private collection

183 *Street, Cassis* 1913
Black conté and ink on paper,
10.8 x 12.1 (4¼ x 5)
Private collection

184 *Two figures and a priest* 1913
Black conté on paper, 22.2 x 17.5
(8¾ x 6⅞)
Signed bottom left
Private collection

185 *Woman with hat and soda siphon*
 1913
Black conté on paper, 22.2 x 17.5
(8¾ x 6⅞)
Signed bottom left
Private collection

186 *Baby with hat* 1914
Oil on paper, 22.2 x 15.2 (8¾ x 6)
Signed bottom left
Private collection

187 *Self portrait* 1914
Conté on paper, 22.2 x 17.1 (8¾ x 6¾)
Signed bottom right
Private collection

188 *Woman's head* 1914
Black conté on paper,
24.7 x 16.5 (9¾ x 6½)
Signed bottom right
Private collection

189 *Head of F C B Cadell* 1917
Black conté on paper, 15.2 x 17.5
(6 x 6⅞)
Signed bottom left
Private collection

190 *Boy with bricks* 1918
Black conté on paper,
22.2 x 14.9 (8¾ x 5⅞)
Signed bottom right
Private collection

191 *Reclining female nude* 1918
Black conté on paper,
27.3 x 24.4 (10¾ x 9⅝)
Signed bottom left
Private collection

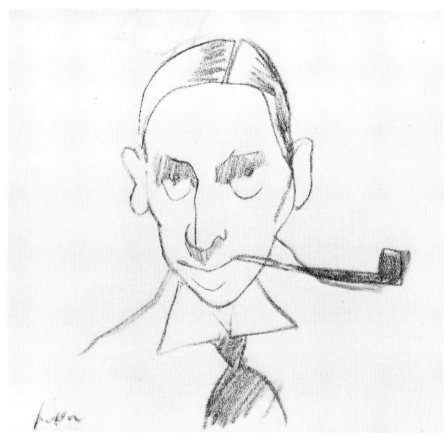

189 Head of F C B Cadell *1917*

200 *Cassis harbour from a distance*
 1924
Black conté on paper,
14.6 x 22.2 (5¾ x 8¾)
Signed bottom right
Private collection

201 *Cassis harbour, masts* 1924
Black conté on paper,
17.4 x 22.2 (6⅞ x 8¾)
Signed bottom right
Private collection

202 *Road with trees, Cassis* 1924
Black conté on paper,
22.2 x 17.4 (8¾ x 6⅞)
Private collection

203 *Schooner, Cassis harbour* 1924
Black conté on paper,
14.9 x 21.9 (5⅞ x 8⅝)
Signed bottom left
Private collection

204 *Windswept landscape* 1924
Black conté on paper,
14.9 x 21.9 (5⅞ x 8⅝)
Signed bottom right
Private collection

205 *Head study* 1925
Red conté on paper,
25.3 x 19 (10 x 7½)
Signed bottom right
Gracefield Arts Centre, Dumfries

206 *Seated nude* 1926
Pencil on paper, 35 x 25
(13¾ x 9⅞)
Signed bottom right
Kirkcaldy Art Gallery

207 *Head of artist's wife with tulips*
 1930
Black conté on paper,
36.8 x 25.3 (14½ x 10)
Signed bottom right
Private collection

208 *Kneeling female nude* 1932
Black conté on paper,
34.3 x 25.4 (13½ x 10)
Signed bottom right
Private collection

209 *Standing female nude backview*
 1932
Black conté on paper,
32.1 x 23.8 (12⅝ x 9⅜)
Signed bottom right
Private collection

192 *Crawling female nude* 1919
Black conté on paper,
36.8 x 25.4 (14½ x 10)
Signed bottom centre
Private collection

193 *Supine female nude* 1919
Black conté on paper,
25.4 x 31.7 (10 x 12½)
Signed bottom right
Private collection

194 *Figure standing at mirror*
 1920
Black conté on paper,
23.5 x 17.1 (9¼ x 6¾)
Signed top left
Private collection

195 *Reclining female nude* 1920
Black conté on paper,
25.3 x 34.9 (10 x 13¾)
Signed top left
Private collection

196 *Self portrait* 1920
Black conté on paper,
25 x 19 (9⅞ x 7½)
Signed bottom right
Private collection

197 *Two dogs* 1920
Black conté on paper,
22.2 x 17.4 (8¾ x 6⅞)
Private collection

198 *Sitting female nude* 1921
Black conte on paper,
34.2 x 22.8 (13½ x 9)
Signed bottom right
Private collection

199 *Three pigs* 1922
Pencil on paper, 12 x 20.3 (4¾ x 8)
Signed bottom left
Private collection
These comic drawings of animals have
strong affinities with similar observations
by Bonnard.

206 Seated nude *1926*

Sketchbooks, photograph albums, books and other items from the artist's studio

210
a. *Kirkcudbright sketchbook:* preparatory sketches
b. *Iona sketchbook:* hens and ducks
c. *Head* c. 1920
 Modern plaster cast from original plasticine, modelled by S J Peploe
d. *The blue pencil*
 Drawing of nightmare scene
e. *Palette*
f. *Painting box*
 This was used on his trip to Brittany
g. *Photograph album of Cassis,* 1913 open at page showing:
 Top right and top left: Anne Rice, Margaret Peploe, Willie Peploe and J D Fergusson
 Bottom right: Anne Rice. Bottom left: Anne Rice, S J Peploe, Willie Peploe and J D Fergusson
h. *Photograph album of Royan, 1910*
 Top right and top left: S J Peploe with his wife Margaret and son Willie. Bottom left: Margaret and Willie Peploe. (Bottom right: Margaret and S J Peploe, Kirkcudbright c. 1920)
i. *A fan*
j. *A selection of Chinese vases*
k. *Plaster cast of the Venus de Medici*
l. *The blue jug*
m. *The yellow jug*
n. *The brown pot*
o. *Dodice Opere di Picasso.* Florence, 1914
 Presented to Peploe by Edward McKnight Kauffer
p. Guillame Apollinaire *Les Peintres Cubistes.* Paris 1913
q. Maurice Raynal: *Picasso.* Munich 1921
r. *The 'Raeburn' chair*
s. *Six photographs of the artist with family and friends*

All the above items have been lent from a private collection.

S J PEPLOE: BRIEF CHRONOLOGY

1871	Born 27 January
1891 -1894	Attended classes at Edinburgh School of Art, L'Académie Julien and L'Académie Colarossi in Paris where he won a silver medal in 1894
1894	Painted on Barra and in Devon
1895	Awarded the MacLaine Watters medal at the RSA Life Class; took a studio in the Albert Buildings in Shandwick Place, Edinburgh
1896	First work, 'Charcoal Drawing', exhibited in Glasgow Institute
1897	Painted on Barra with R C Robertson; had his first painting exhibited in the Glasgow Institute; first painting sold through Aitken Dott & Son
1900	Short holiday in Paris before moving studio to 6 Devon Place, Edinburgh
1902	Painted in Comrie
1903	Painted in North Berwick in July, Comrie in September and Barra in early November; exhibition at Aitken Dott & Son in October. (From the 1870's onwards Aitken Dott & Son held exhibitions under the name *The Scottish Gallery*)
1904	First Brittany painting holiday with J D Fergusson
1905	Studio at 32 York Place, Edinburgh, built by Henry Raeburn in 1795 for his portrait painting requirements
1907	Painted in Paris Plage and went on to Paris; had a picture bought by the newly formed Scottish Modern Arts Association from the RSA
1909	Second exhibition at Aitken Dott & Son
1910	Married Margaret Mackay and shortly afterwards moved to Paris to a studio apartment at 278 Boulevard Raspail
1910	Painted at Royan where his first son Willie was born
1911	Painted on the Île de Bréhat and at Cassis and returned alone to Edinburgh in July to raise money
1912	The Peploe family returned to Edinburgh in June and bought a flat at 13 India Street. Peploe took a new studio at 34 Queen Street
1913	Exhibited at the New Gallery, Shandwick Place, Edinburgh; painted on Arran and again at Cassis
1914	Second son, Denis, born; painted at Crawford
1915	Painted at Kirkcudbright
1917	Elected Associate of the RSA
1918	Studio at 54 Shandwick Place
1919	Painted at Douglas Hall, Dumfries and Galloway
1920	First of regular visits to Iona
1923	First of two group shows at the Leicester Galleries
1924	Painted at Cassis with family and F C B Cadell at Hôtel Panorama
1925	Painted at New Abbey
1927	Elected Member of the RSA
1928	Painted at Antibes and Cassis, and at Sweetheart Abbey in Dumfriesshire; exhibition in New York at C W Kraushaar Art Gallery
1931	Painted at Kirkcudbright for the last time
1932	Took a studio on corner of Queen Street and Castle Street
1933	Taught advanced life class students at Edinburgh College of Art for four terms; painted at Calvine and Blairfettie in Perthshire, staying with Mr and Mrs A G Sinclair
1934	Painted at Rothiemurchus and became increasingly ill
1935	Died on 11th October and was buried at the Dean Cemetery, Edinburgh

IMPORTANT EXHIBITIONS

Unless otherwise stated, all exhibitions are one man shows.

1903 November 3-December 1
Aitken Dott & Son, Edinburgh

1909 March *Exhibition of Painters and Drawings by S J Peploe*
Aitken Dott & Son, Edinburgh

1911 May-June *Group Exhibition of six artists*
Aitken Dott & Son, Edinburgh

1912 February *Drawings by S J Peploe*
Stafford Gallery, London

1912 October *Pictures by S J Peploe and eight other artists including J D Fergusson*
Stafford Gallery, London

1913 2-24 May
New Gallery, Edinburgh

1914 April (Group Exhibition)
Baillie Gallery, London

1915 November
Alex Reid, Glasgow

1919 November-December
Alex Reid, Glasgow

1921 February
Alex Reid, Glasgow

1921 December
Alex Reid, Glasgow

1922 February-March
Aitken Dott & Son, Edinburgh

1923 January *Exhibition of Paintings by S J Peploe, F C B Cadell, and Leslie Hunter*
The Leicester Galleries, London

1923 December
Aitken Dott & Son, Edinburgh

1924 February-March
Aitken Dott & Son, Edinburgh

1924 March
Alex Reid, Glasgow

1924 June 2-15 *Les Peintres de l'Écosse Moderne, F C B Cadell, J D Fergusson, Leslie Hunter and S J Peploe*
Galerie Barbazanges, Paris

1925 January *Exhibition of Paintings by S J Peploe, Leslie Hunter, F C B Cadell and J D Fergusson*
The Leicester Galleries, London

1926 January 23-March 13 *Dunfermline Fine Art Exhibition* (Group Exhibition)
Dunfermline Art Club and Carnegie Dunfermline Trust

1926 April-May
Alex Reid, Glasgow

1926 December
Alex Reid, Glasgow

1927 December
Aitken Dott & Son, Edinburgh

1928 January 23-February 3 *Exhibition of Paintings by S J Peploe*
C W Kraushaar Art Galleries, New York

1928 July-August *Second Inaugural Loan Exhibition*
Museum and Art Gallery, Kirkcaldy

1929	May Alex Reid & Lefevre, Glasgow
1929- 1930	December to January Alex Reid & Lefevre, London
1930	March Aitken Dott & Son, Edinburgh
1931	March 1-14 *Les Peintres Écossais, S J Peploe, J D Fergusson, Leslie Hunter, F C B Cadell, Telfer Bear, R O Dunlop* Galeries Georges Petit, Paris
1931	April Alex Reid & Lefevre, Glasgow
1932	April-May *Paintings by Six Scottish Artists, Peploe, Hunter, Fergusson, Cadell, Bear, Gillies* Barbizon House, London
1933	January 12-February 1 *Society of Eight, Twenty-first Exhibition* (Group Exhibition) New Gallery, Edinburgh
1934	February-March *Catalogue of a few recent paintings by S J Peploe, RSA* Alex Reid & Lefevre, London
1934	February Aitken Dott & Son, Edinburgh
1934	April-May Pearson & Westergaard, Glasgow
1936	April-May *Memorial Exhibition* Aitken Dott & Son, Edinburgh
1937	February *Memorial Exhibition* Arranged by Alex Reid & Levefre, London, in conjunction with Pearson & Westergaard, Glasgow McLellan Galleries, Glasgow
1938	April-October *The Fine Art Section of the Empire Exhibition, Glasgow* Palais of Arts
1939	January *Three Scottish Painters, S J Peploe, Leslie Hunter, F C B Cadell* Alex Reid & Lefevre, London
1939	January-March *Exhibition of Scottish Art* (Group Exhibition) Royal Academy of Arts, Burlington House, London
1941	March *S J Peploe, 1871* National Gallery of Scotland, Edinburgh
1947	April 21-May 7 *Exhibition of oil paintings by S J Peploe, RSA* Ion MacNicol Galleries, Glasgow
1947	August 18-September 13 *Paintings and Drawings by S J Peploe, RSA* Aitken Dott & Son, Edinburgh
1948	May *Paintings by S J Peploe* Alex Reid & Lefevre, London
1948	November *Paintings by Four Scottish Colourists* T & R Hannan & Sons, Glasgow
1949	August-September *S J Peploe, RSA; F C B Cadell, RSA; and Leslie Hunter.* Festival Exhibition Royal Scottish Academy, Edinburgh
1950	September *Exhibition of Paintings by Cadell, Hunter and Peploe* Ion MacNicol Galleries, Glasgow

1951 March 2-27 *Pictures from a private collection* (Group Exhibition)
 Thistle Foundation, Honorary organisers T & R Annan & Sons, Glasgow

1952 August-September *Festival Exhibition* (Group exhibition)
 Aitken Dott & Son, Edinburgh

1952 April 16-September 7 *Four Scottish Colourists: Peploe, Cadell, Hunter, Fergusson*
 Saltire Society, Gladstone's Land, Edinburgh

1953 April *S J Peploe, 1871-1935*
 Arts Council—Scottish Committee Touring Exhibition

1961 October 5-November 30 *Scottish Painting*
 Glasgow Art Gallery

1977 February 19-March 19 *Three Scottish Colourists*
 The Fine Art Society, Edinburgh
 March 29-April 22 same show in Fine Art Society, London

1980 March-June *The Scottish Colourists*
 Organised by Guildford House Gallery, the show also travelled to Hull and
 Stoke

BIBLIOGRAPHY

This Bibliography was compiled by Ailsa Tanner for *Three Scottish Colourists*, 1970, a Scottish Arts Council touring exhibition which was selected by T J Honeyman and had an introductory essay by W R Hardie. It has been updated to 1980, including posthumous newspaper articles.

Books

Scottish Painting—Past and Present 1620-1908, London 1908	pp. 451-452	Sir James L Caw
Memories of Swinburne with other essays, Edinburgh 1910	pp. 36-43	W G Blaikie Murdoch
A History of Painting, Vol. VIII. The Modern Genius, London 1911	pp. 258-259	Haldane Macfall
Cubists and Post Impressionism, London 1915	p. 47	Arthur Jerome Eddy
Modern Movements in Painting, London 1920	pp. 155-156	Charles Marriott
The Arts of Scotland, London 1938	pp. 93-96	John Tonge
Peploe: An intimate memoir of an artist and his work, London 1947		Stanley Cursiter
Art in Scotland, London 1948	pp. 147-150	Ian Finlay
Three Scottish Colourists, London 1950	pp. 49-70	T J Honeyman
Scottish Painting 1837-1939, 1976	Chapter 8	William Hardie
The Eye in the Wind 1977	pp. 15-16	Edward Gage

Periodicals

Apollo (January 1930) Vol. XI	Art News and Notes. New Paintings by S J Peploe; p. 69	Herbert Furst
Apollo (April 1931) Vol. XIII	Letter from Paris (Review of 'Les Peintres Écossais',Galeries Georges Petit, Paris); pp. 240-242	André Salmon
Apollo (February 1939) Vol. XXIX	Round the Galleries. Three Scottish Painters . . . at Messrs Alex Reid & Lefevre's Galleries; pp. 98-99	Herbert Furst
Art Journal (January 1909)	London Exhibition, Goupil Gallery Salon; pp. 26-27	
Art Work (1926) Vol. II No. 7	Recent Art Exhibitions Dunfermline Fine Art Exhibition; p. 141	W Egerton Powell
The Artist (December 1935) Vol. X	S J Peploe, RSA; pp. 123-124	T J Honeyman
Colville's Magazine (July 1939) Vol. XX No. 7	S J Peploe, RSA; pp. 153-155	T J Honeyman
Creative Art (February 1931) Vol. 8	Work of S J Peploe; pp. 103-108	Gui St Bernard

The Daily Telegraph (7 December 1929)	Peploe's Paintings	R R Tatlock
The Daily Record and Mail (4 February 1937)	S J Peploe pictures	
Evening Citizen (24 April 1931)	Mr Peploe's Art	MEL (T J Honeyman)
The Evening News, Glasgow (4 February 1937)	Dazzling Genius of Peploe	
Evening Times (9 May 1936)	Lifetime of Painting	W J Weir
Glasgow Herald (13 November 1915)	Mr Peploe's Pictures; p. 11d	
Glasgow Herald (28 November 1919)	The Art of Mr Peploe; p. 4h	
Glasgow Herald (17 December 1921)	The Art of Mr Peploe; p. 5f	
Glasgow Herald (11 January 1923)	Art in London — Three Scottish Artists; p. 3d	
Glasgow Herald (3 April 1924)	Paintings by S J Peploe; p. 5d	
Glasgow Herald (8 December 1926	Mr Peploe's Art; p. 13d	
Glasgow Herald (12 April 1934)	S J Peploe's Art; p. 6c	
Glasgow Herald (14 October 1935)	Obituary; p. 13c	
Glasgow Herald (25 April 1936)	The late Mr S J Peploe	
Glasgow Herald (6 February 1937	Tribute to the late S J Peploe, RSA	
Glasgow Herald (19 August 1947)	Peploe Exhibition of Painting	
Glasgow Herald (5 December 1953)	Exhibition of Peploe paintings	
Listener (18 March 1948)	Review of Peploe: (by Stanley Cursiter)	
National Gallery of South Australia Bulletin (January 1956) Vol. 17 No. 3	Still life with pears and wine glass	
Outlook (June 1936) Vol. 1 No. 3	A great Scottish artist; pp. 90-91	J H W
Outlook (January 1937) Vol. 1 No. 10	S J Peploe, RSA; pp. 46-50	David Foggie
Royal Scottish Academy 108th Annual Report 1935	Samuel John Peploe (obituary); pp. 13-15	
Scotland (October 1947) Vol. 8	Peploe (Review of Peploe; by Stanley Cursiter)	T J Honeyman
Scotland's SMT Magazine (1948) Vol. 41 No. 2	Peploe (Review of Peploe; by Stanley Cursiter); p. 33	Douglas Percy Bliss
Scots Observer (1932)	Contemporary Scots Art; p. 13 (reprint)	
Scotsman (14 October 1935)	Obituary	
Scotsman (14 October 1935)	Peploe's Art	David Foggie

Scotsman (8 May 1936)	S J Peploe, RSA, Posthumous Exhibition	David Foggie
Scotsman (15 October 1935)	An Appreciation: S J Peploe	F P (Frederick Porter)
Scotsman (16 August 1947)	Paintings by Peploe	
Scotsman (23 April 1953)	S J Peploe	
Scottish Art Review (1962) Vol. VIII No. 3	Memories of Peploe; pp. 8-12, 31-32	J D Fergusson
Scottish Art Review (1948) Vol. II No. 1	A Great Scottish Colourist; pp. 28-29 (Review of Peploe by Stanley Cursiter)	T J Honeyman
Scottish Art Review (1957) Vol. VI No. 2	Kirkcaldy's Riches; pp. 7-10	A R Sturrock
Standard (12 February 1912)	Art Exhibitions (Stafford Gallery)	
Studio (1904) Vol. XXX	Studio Talk—Edinburgh; pp. 161, 346	J L C (James L Caw)
Studio (1912) Vol. LV	Studio Talk—London; pp. 227-228	
Studio (1912) Vol. LVI	Studio Talk—London; pp. 223-224	
Studio (1914) Vol. LXI	Studio Talk—Edinburgh; p. 65	
Studio (1914) Vol. LXI	Studio Talk—London; p. 232	
Studio (1917) Vol. LXX	Studio Talk—Edinburgh; p. 43	A E (A Eddington)
Studio (1920) Vol. LXXVIII	Studio Talk—Glasgow; pp. 120-124	
Studio (February 1924) Vol. LXXXVII	S J Peploe, RSA; pp. 63-64	E A Taylor
Studio (1927) Vol. XCIII	London Notes; pp. 119-120	A L B
Studio (1931) Vol. CI	The Work of S J Peploe; pp. 105-108	Gui St Bernard
Studio (August 1941) Vol. CXXII	Art News and Exhibitions, Scotland, The National Gallery; pp. 48-49	Rathbone Holme
Studio (1948) Vol. CXXXVI	London Commentary; p. 55	Cora Gordon
The Times (May 1948)	Paintings by S J Peploe; p. 3	
The Times Literary Supplement (3 January 1948)	Review of Peploe; p. 7	

Exhibition catalogues

Exhibition of Paintings by S J Peploe, C W Kraushaar Art Galleries, New York, January 1928	Autobiography	S J Peploe
Second Inaugural Loan Exhibition, Museum and Art Gallery, Kirkcaldy, July 1928	p. 10	Biographical note by T Corsan Morton

Memorial exhibition of eighty-three paintings by S J Peploe, RSA, Aitken Dott & Son, Edinburgh, April-May 1936	Foreword; pp. 3-4	James L Caw
Memorial Exhibition of Paintings by S J Peploe, RSA, McLellan Galleries, Glasgow, February 1937	Foreword; pp. 3-4	E A Taylor
S J Peploe 1871-1935 National Gallery of Scotland, Edinburgh, March 1941	Introduction; pp. 2-4	S C (Stanley Cursiter)
Paintings and Drawings by S J Peploe, RSA, Aitken Dott & Son, Edinburgh August 1947	Introduction	J W Blyth
Paintings by S J Peploe Alex Reid & Lefevre, London, May 1948	Foreword	S Cursiter
S J Peploe 1871-1935 Arts Council—Scottish Committee 1953	Introduction; pp. 3-4	Denis Peploe
Exhibition of Paintings by S J Peploe, Leslie Hunter, F C B Cadell and J D Fergusson. The Leicester Galleries, London, January 1925	Preface	Walter Sickert
Paintings by Six Scottish Artists, Barbizon House, London, April-May, 1932	Appreciation; pp. 2-4	Gui St Bernard
Three Scottish Painters— S J Peploe, Leslie Hunter, F C B Cadell, Reid & Lefevre, London, January 1939	Foreword; pp. 1-2	Douglas Percy Bliss
Paintings by Four Scottish Colourists, T & R Annan & Sons, Glasgow, November 1948	Introduction	T J Honeyman
Pictures from a Private Collection. Thistle Foundation, Glasgow 1951	Preface; pp. 7-8	Stanley Cursiter
Four Scottish Colourists, Saltire Society, Edinburgh, 16 August-7 September 1952	Foreword (2 pp.)	Ian Finlay
Three Scottish Colourists. Scottish Arts Council 1970	Introduction; pp. 7-12	William Hardie
Three Scottish Colourists Peploe/ Cadell/Hunter. The Fine Art Society Ltd., Edinburgh, February-March 1977 London, March-April 1977	Introduction	Richard Calvocoressi
The Scottish Colourists, Guildford House Gallery. Toured March-June 1980	Introduction	Richard Calvocoressi

LENDERS

The Hon. James Bruce	7, 162, 165, 168, 171
Robert Fleming Holdings Ltd.	45, 79, 127, 131
Mr and Mrs Tim Honeyman	56
Mr and Mrs Clark Hunter	87, 112
Mr and Mrs John B Rankin	78
J T R Ritchie	61, 63, 88, 89
Aberdeen Art Gallery and Museums	90, 116
Dumfries, Gracefield Arts Centre	128, 145, 205
Dundee Art Galleries and Museums	29
City of Edinburgh Art Centre	31, 117
The Governors of Edinburgh College of Art	2
The Royal Scottish Academy	85
Scottish National Gallery of Modern Art	14, 18, 30, 35, 37, 49, 51, 55, 62, 83, 84, 92, 93, 101, 125, 130, 140
Scottish National Portrait Gallery	16
The University of Edinburgh	123
The Burrell Collection, Glasgow Museums and Art Galleries	8
Fine Art Society, p.l.c.	34, 120
Glasgow Art Gallery and Museum	9, 27, 70, 81, 86, 94, 96, 152
Hunterian Art Gallery, University of Glasgow	95, 97, 148
The Maclean Museum and Art Gallery, Greenock	76
The University of Hull Art Collection	69
Kirkcaldy Art Gallery	3, 12, 19, 25, 26, 40, 47, 48, 52, 72, 74, 105, 111, 121, 122, 126, 156, 206
Manchester City Art Galleries	107
Perth Museum and Art Gallery	124
Stoke-on-Trent, City Museum and Art Gallery	67

Private collections

1, 4, 5, 6, 10, 11, 13, 15, 17, 20, 21, 22, 23, 24, 28, 32, 33, 36, 38, 39, 41, 42, 43, 44, 46, 50, 53, 54, 57, 58, 59, 60, 64, 65, 66, 68, 71, 73, 75, 77, 80, 82, 91, 98, 99, 100, 102, 103, 104, 106, 108, 109, 110, 113, 114, 115, 118, 119, 129, 132, 133, 134, 135, 136, 137, 138, 139, 141, 142, 143, 144, 146, 147, 149, 150, 151, 153, 154, 155, 157, 158, 159, 160, 161, 163, 164, 166, 167, 169, 170, 172, 173, 174, 175, 176, 177, 178, 179, 180, 181, 182, 183, 184, 185, 186, 187, 188, 189, 190, 191, 192, 193, 194, 195, 196, 197, 198, 199, 200, 201, 202, 203, 204, 207, 208, 209, 210a-s.

Printed in Scotland for Her Majesty's Stationery Office by
Blackwood Pillans & Wilson 762102/4541 C50 6/85